D1536295

THE GUIDE TO THE ART OF
ROCKEFELLER CENTER

CHRISTINE ROUSSEL

PHOTOGRAPHS BY DIANNE ROUSSEL
AND CHRISTINE ROUSSEL

W. W. NORTON & COMPANY · NEW YORK · LONDON

51ST STREET

1270 AVENUE OF THE AMERICAS

RADIO CITY MUSIC HALL

ASSOCIATED PRESS BUILDING

INTERNATIONAL BUILDING NORTH

INTERNATIONAL BUILDING

PALAZZO D'ITALIA

50TH STREET

AVENUE OF THE AMERICAS

1250 AVENUE OF THE AMERICAS

30 ROCKEFELLER PLAZA

ROCKEFELLER PLAZA

SKATING RINK & LOWER PLAZA

BRITISH EMPIRE BUILDING

CHANNEL GARDENS AND PROMENADE

LA MAISON FRANÇAISE

FIFTH AVENUE

49TH STREET

10 ROCKEFELLER PLAZA

ONE ROCKEFELLER PLAZA

48TH STREET

N

As a New Yorker born and bred, I have always considered Rockefeller Center to be the single most dynamic and exciting place in the city. Over the years I have made countless visits to Radio City Music Hall, to various Christmas trees, to radio and television studios, and even to one of my dentists, a visit that seemed less daunting because at least I could revel in the Art Deco details of the buildings. Rockefeller Center is not only a singular architectural triumph; it is a stunning gallery of art.

I was taken there in 1939 when I was eight years old, not long after John D. Rockefeller Jr. had hammered in the last rivet on the fourteenth and final structure of the vast, sleek, streamlined complex. I remember marveling at the remarkably clean stone of the towering buildings, which seemed amazingly to be in human scale. I also recall vividly several sculptures because they triggered a host of dreams—one was of a huge man, *Atlas*, hoisting an enormous bunch of circles into the air. Another, *Prometheus*, lavishly gilded, seemed to be watching over us skating in the rink.

The Center is in a sense like the early Gothic cathedrals of France, richly decorated with sculpture, stained glass, and murals portraying religious and secular life. In the case of Rockefeller Center, the message was not the Old and New Testaments but themes appropriate to the cathedral of industry and modern times. The people who created the iconographic schemes were striving to illustrate "New Frontiers" and "The March of Civilization." The artists chosen to carry out the work succeeded admirably. Works by such artists as Paul Manship, Lee Lawrie, José María Sert, Isamu Noguchi, and Gaston Lachaise are perfect examples of their genius. Lachaise's stalwart, buck-naked construction workers are a wonder.

Which Rockefeller Center works would I like to sneak into my private collection? For sure, I would want Lee Lawrie's hulking, chunky-muscled *Atlas*, his brows deeply furrowed in his perpetual struggle to hold the globe. Of course, Paul Manship's triumphant, sleek, shimmering *Prometheus*. And, naturally, all six of the sprightly and witty bronze fountainheads of a stunning variety of real and imagined sea creatures by Rene Chambellan for the pools in the Channel Gardens.

And maybe even—if I had the space—Sert's dramatic replacement for Diego Rivera's gigantic fresco with its dreaded visage of Lenin. Sert's mural, *American Progress*, portrays Abraham Lincoln, Ralph Waldo Emerson, and, in the background, the towers of divine Rockefeller Center as a symbol of modern America, which the Center still happens to be.

—Thomas Hoving

USING THE GUIDE

This guidebook is designed to help the visitor easily locate and enjoy the public art of Rockefeller Center. It is intended to be used for self-guided tours that can be adapted to the individual's time and interests. It is divided into fourteen chapters, each devoted to the art in a single building, starting with the earliest one built. There is a general map on page 2, opposite the table of contents, providing an overview of Rockefeller Center. It orients the visitor, locating and identifying every area and building by color code.

Most of the art has been photographed. Information regarding each piece (artist, media, size, foundry, date, etc.) is provided with the text in the margins. At the end of the guide, there is an alphabetical list of artists that enables the reader to easily locate and single out the work of a specific artist. Biographical information regarding the artists is also included.

I hope that this guide goes beyond the Center, and serves as an inspiration to look up and see the art and ornamentation found on buildings throughout the world.

—Christine Roussel

In 1929, America was in the depths of the Great Depression when John D. Rockefeller Jr. found himself the lone investor in the building of Rockefeller Center. It was an extraordinary, visionary act of financial judgment and risk-taking for a single person. He resolved that the world's largest private building project would be built with the best materials, experts, labor, and modern equipment. It would be contemporary, innovative, and luxurious in its design and ornamentation.

This ornamentation included an art program that was envisioned by John D. Rockefeller Jr. as a necessary component of his city-within-a-city. He formed an art committee to have knowledgeable, distinguished people available to the project. A theme was needed that would create a harmonious art program. The prominent scholar and philosopher Professor Hartley Burr Alexander was consulted. He proposed the main theme, "New Frontiers." His concept was subdivided into four sub-themes: "Man's Progress toward Civilization," "Man's Development in Mind and Spirit," "Man's Development in Physical and Scientific Areas," and "Man's Development of Industry and the Character of the Nation."

The art program became so far-reaching that specialists from the art world and fields of interior and industrial design were hired to oversee and coordinate aspects of the project. These professionals were to work within the themes, organizing each phase of the art program. Donald Deskey, the famed interior and industrial designer, was commissioned to design the interior and furnishings of the world's largest theater, Radio City Music Hall. He hired and supervised other artists and craftsmen and endowed the theater with "sane, modern design" as differentiated from "modernistic design." Edward Trumbull, a well-known muralist, was hired as color director to oversee the aesthetics of all the other buildings' interiors. He recommended artists, selected materials, and provided color coordination, ensuring that the Center's interiors were in decorative harmony. Leon V. Solon, a designer and color expert, was hired as an exterior color coordinator. He provided materials and suggested methods as well as the color palette that embellished and unified the exterior carved stone artwork. More than forty additional artists worked on specific projects. They worked in a vast range of media including oil-painted murals, mosaics, metal, and

enamel works; sculptures in bronze, aluminum, wood, stone, stainless steel, and glass; and gilded works, fabrics, fountains, and polychrome-painted works. The art program resulted in a scale of ornamentation and art-in-architecture unprecedented in any private urban project. Rockefeller Center was to be greater than its parts, more than a group of commercial buildings. It was to be a carefully, and thoughtfully, planned entity bonded by architectural design, ornamentation, and art. Many people consider it the very heart of New York.

ACKNOWLEDGMENTS

This guide came about as result of the many commissions my company, Roussel Studios, received to restore the public art in Rockefeller Center. In the course of restoring these works, I discovered there was no comprehensive guide to the art. That led me to begin researching and documenting the art and artists, object by object. The guide is a result of those efforts. My daughter Dianne photographed most of the pieces in the guide. She has been devoted to the project and brought her extensive skills as a designer and photographer to it. The book would not have been possible without the behind-the-scenes support of Laurance and David Rockefeller. I am especially indebted to Wesley Frey Jr. and Peter Johnson of the Rockefeller Family Offices. Tom Madden of Tishman-Speyer Properties generously helped arrange access to the buildings. Over a three-year period, Glenn Mahoney, director of special events for Rockefeller Center, provided information and valuable assistance. Sandra Manley, assistant vice president of corporate communications, and Vincent Silvestri, chief administrative officer of the Rockefeller Group, Inc., provided access to the archives. I owe a great debt to archivist James Reed for the many years of experience he generously shared with me and in whose capable hands resides the Rockefeller Center Archive Center. My son Marc has restored many of the pieces in the Center and willingly contributed his expertise. Without the guidance of Robert Lescher, my literary agent and a most generous man, none of this would have come to pass. Once again Robert L. Wiser has designed the book I dreamed. Working with James Mairs, senior editor at W. W. Norton, has been a great pleasure and learning experience. Step by step he guided the process and brought this book to print. Thank you all so very much.

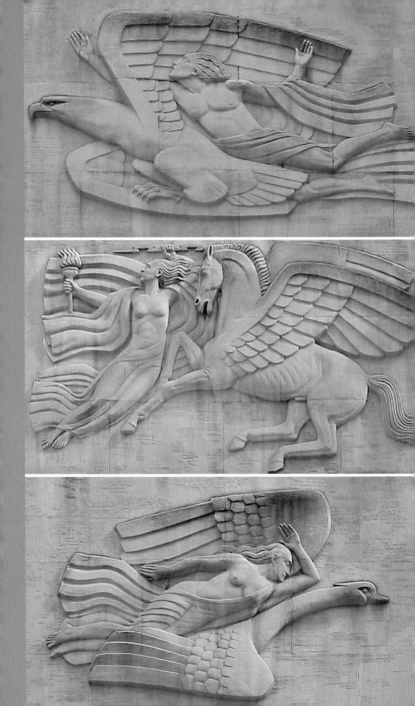

This was the first work of art commissioned for Rockefeller Center. It set the stage for the Art Deco style that was to become aesthetically synonymous with the Center. The three limestone panels are allegories of time and evocative of radio's vast reach and never-ending transmission. Symbolizing radio was appropriate since the first tenant in this building was the Radio Corporation of America (RCA). At that time in America, radio was a recent development and was fast becoming a powerful means of communication because there were no barriers—its signal can be constant and its range infinite. The Rockefellers recognized its worldwide importance and wanted to highlight its advent with these three bas-reliefs. The south-panel main figure represents *Morning*. He is a strong youth who is depicted with his face and arms uplifted to welcome the day. He is conveyed on the wings of an eagle that, like radio waves, relentlessly flies through the air. The eagle is iconic of America's strength, and in this panel symbolizes the power of radio. The central-panel figure represents *Present*. This classically draped woman is depicted soaring upward through space accompanied by the mythological winged horse Pegasus. In her right hand she holds a torch whose stylized flames personify the transmission of knowledge. As she hastens through the day, her hair ripples outward. She holds an electric bolt aloft, symbolic of the speed of radio waves. The prancing Pegasus is identified with inspiration. The north panel depicts *Evening*. It completes the time cycle and radio's endless transmission. The figure rests on the wings of a heronlike bird that effortlessly glides through the night sky. His eyes are closed and he holds one arm protectively in front of his face, the other behind him as if pushed by the flow. In the past the panels provided identity to the building's tenants. Nowadays, their rich array of symbols are purely Art Deco architectural embellishments.

MORNING, PRESENT, EVENING

Robert Garrison
(1895–1946)

Installed
November 1932

Type
Bas-relief

Medium
Limestone

Measurements
Each panel 21 feet long

Location
Above 1270 Avenue of the Americas entrance

SENTINELS

Robert Kushner
(1949–)

Type
Sculpture

Media
Bronze

Fabricator
Tallix Morris Singer
Foundry, Beacon,
New York

Architect
Hellmuth, Obata,
Kassabaum (HOK)

Measurements
Range from 12 feet
to 16 feet wide

Location
Main lobby near ceiling

In 1990, Rockefeller Center undertook an extensive renovation of the lobby of 1270 Avenue of the Americas. They sought the help of the Art Advisory Service of the Museum of Modern Art to locate an artist whose work would be suitable for the lobby and distinguish the space. This search resulted in the selection of Robert Kushner, who created three winged spirits. He termed his figures *Sentinels*, implying they are silent, heavenly guardians of the building. They were placed high on the walls near the ceiling and above the entrances. Kushner referred to his method of creating the figures as "negative cutouts." He hand-carved patterns of the openwork figures into flat, one-sided hardened sand molds that were laid flat on the foundry floor. The figures were then cast by pouring molten bronze into these molds. Some of the molten bronze overflowed the molds, creating foil-like excesses. Kushner incorporated the delicate overruns into the design, making the figures more ethereal. Finally, the figures were colored with a blue-green patina, gently contrasting them with the gilded ceiling. As a result, his figures appear drawn or sketched like caricatures in a golden dreamland. In spite of their originality and delicacy, they verge on being endearing, perhaps overly sweet, creating a most unusual ambience for a commercial lobby.

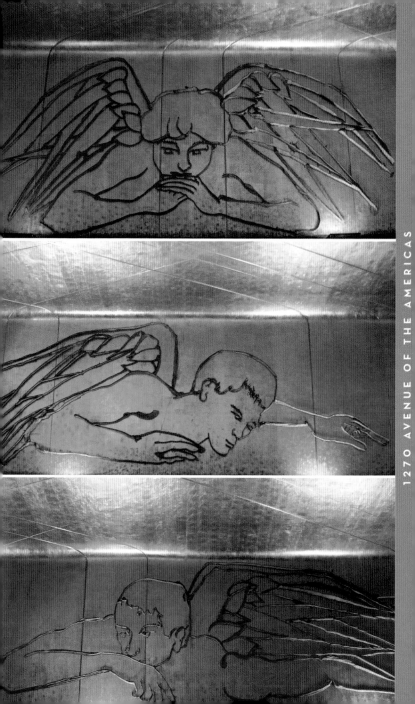

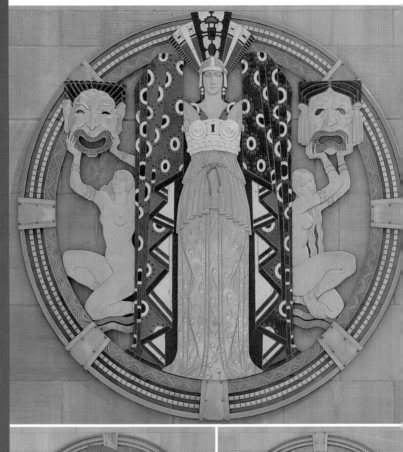

Placed high up on the south façade of Radio City Music Hall are three large stylized decorative plaques, representing the main activities of theater: dance, drama, and song—the creative forces that foster civilization. The plaques are the designs of Hildreth Meiere, who collaborated with the famed metalworker Oscar B. Bach. As a first step, Meiere created a series of small, very detailed studies. Her final gouaches were used by Bach as a blueprint for fabrication in metal and coloration in enamel on a scale never before attempted. Working from Meiere's full-size cartoons, Bach created each form in a variety of both traditional and new lightweight modern metals such as aluminum that were cut, formed, hammered, and embossed to create a variety of textures and reflective qualities. Once the different shapes were completed, Bach followed Meiere's direction to color various elements using polychrome-enamel. The metal parts were joined by riveting or soldering the edges. The results were brilliant. In *Dance*, the female figure frolics across the plaque holding cymbals high in the air. Her red hair swirls above her head and onto the surrounding border. The gallant Roman figure behind her wears a feathered helmet, golden skirt, and colorful cloak. He prances across the plaque while supporting a flying drape that shields her nude body. The figures' positions suggest movement and graceful action. The middle plaque *Drama* contains three figures. The central figure is the essence of the Art Deco style. She wears an elaborate headdress and her face is serenely neutral, personifying drama. She is poised in a frontal position with her perfect figure apparent through a diaphanous gown. Wearing a golden helmet and breastplate, she holds a jazzy multicolored robe aloft. Kneeling flanking silver figures raise the masks of comedy and tragedy. The third plaque *Song* contains two figures in a gentle harmonious setting. The female figure gracefully raises her arms toward fluttering birds while her drape softly floats around her nude body. Her seated male partner plays the flute and appears to be lost in his music. The combination of metals, textures, colors, and playful style in the plaques punctuates the pristine space and breaks the monotony of the plain limestone façade. The art invites the passerby to Radio City Music Hall—it's an exciting place!

DANCE, DRAMA, AND SONG

Hildreth M. Meiere
(1893–1961)

Installed
1932

Type
Plaques

Size
Eighteen feet in diameter

Fabricator
Oscar Bruno Bach

Media
Carbon steel, copper, aluminum, chrome-nickel steel, vitreous enamel, gold, and silver gilding

Location
Fiftieth Street façade

RADIO CITY MUSIC HALL

ACTS FROM
VAUDEVILLE

Rene Paul Chambellan
(1893–1955)

Installed
1932

Type
Openwork plaques

Foundry
The Gorham Company,
Providence, Rhode Island

Media
Cast bronze

Location
Under marquee and
above 1260 Avenue of
the Americas entrance

Don't miss the six playful plaques under the marquee on the granite wall. Look up and across the top of the entrances to the theater. These plaques are both architectural decorations and introductions to the amusements and stage events ahead. The imaginative plaques represent scenes typical of international ethnic performances of the early twentieth century. The countries and acts are easily recognizable from the characteristic accessories and careful depiction of native costumes. Viewing the plaques from north to south: five Russian minstrels and a gypsy dancer; two black banjo players with a tap dancer; a seated German accordionist with a saxophonist playing for a smug-looking cat; five American dancers (the Rockettes) precision-kicking; a French cellist with a female violinist playing for a dog in a clown costume doing tricks; a seated Jewish drummer and a dancer in top hat and tails holding a cane. Even when commissioned to portray such stereotypical themes as found in *Acts from Vaudeville*, Rene Chambellan's work displays spontaneity and sophistication. Never trite, the plaques are amusing and welcoming. Chambellan was recognized by other artists and the Center's builders as a master technician and sculptor. He was commissioned to create a number of major works and to model nearly all the architectural details, such as grilles, handrails, moldings, and elevator cabs and doors found in the Center.

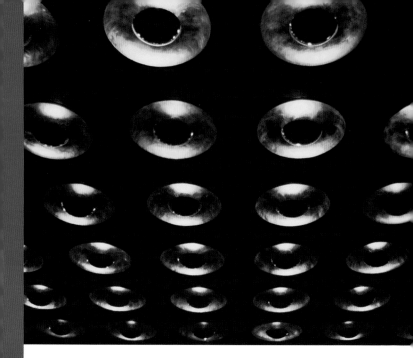

TICKET LOBBY LIGHTS

Donald Deskey
(1894–1989)

Type
Interior design

Location
Ticket lobby

The ticket lobby is the first area the visitor enters; it is lit by a series of circular gilded lights set into a low, dark glazed, copper-leafed ceiling. The low restricted area was conceived of by the architect, Edward Durrell Stone, and is enhanced by Donald Deskey's sumptuous use of these lights set into a pattern of even rows in the gilded ceiling. It is a modernistic statement that combines utility with beauty. The profusion of lights is an extravagant gesture. The low ceiling and sloping entrance serve as both a passage and as an understated prelude to the spectacular soaring grand foyer and sweeping 180-degree arches of the enormous auditorium. The ticket lobby effectively changes the milieu, ushering the visitor from the New York streets to an atmosphere of anticipation—dazzling, glamorous show business is just ahead.

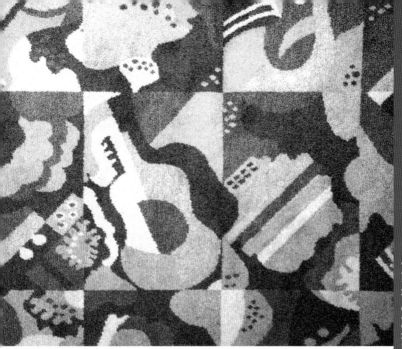

Deskey commissioned the textile designer Ruth Reeves to create a design for a vast carpet that would cover the grand lobby, staircase, and three mezzanines—and be symbolic of theatrical activities. In a mosaiclike configuration, Reeves interwove strong geometric abstractions of musical instruments. The rhythmical patterns, with a colorful concoction of geometrically shaped banjos, guitars, accordions, piano keys, saxophones, and harps, float against ample clouds of bright orange and yellow in a deep blue sky. Because of the huge size of the carpet, strong patterns, and bold bright colors, it is almost visual overload. At first glance the instruments are not easy to discern. Each musical motif is set into and defined in an irregular-shaped block. Reeves' interlocking and overlapping shapes, undulating lines, sinuous curves, and dots contribute an organic facet to the design, thwarting any mechanical appearance. The result is an immense, jazzy carpet that is opulent and urbane. It is perfect for a public pleasure palace.

GRAND LOBBY CARPET

Ruth Reeves
(1892–1966)

Installed
1932 (replaced 1999)

Type
Carpet

Medium
Synthetic-fiber carpet

Locations
Between grand lobby stairs and mezzanines

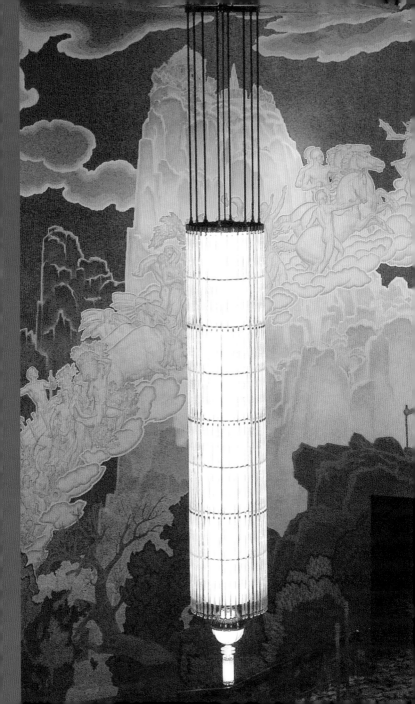

Two extraordinary huge chandeliers and wall sconces of similar size and design grace the main lobby. The wall sconces are hung on tinted mirrors that magnify their size and softly reflect light. The chandeliers are the main event. They are formed by forty long glass rods held together by internal metal bands resulting in an elongated cylindrical shape. Light is defused through the rods and open spaces, generating a soft white glow. They are suspended from nine metal tubes originating from a raised disk in the ceiling. At the bottom of the chandelier a ball made from curved pieces of glass and a tassel made of small glass rods hang from the center. The massive chandeliers and wall sconces enhance the space and underscore the notion of a pleasure palace where nothing is too majestic, too big, or too lavish—where the visitor is surrounded by glittering opulence. The company that designed the lighting fixtures also manufactured them. Although its founder, Edward F. Caldwell, is frequently credited with this design, he died in 1914, many years prior to this commission. Under his leadership the company had established an outstanding reputation for creating monumental commercial lighting fixtures, metalware, and accessories. The firm, under the direction of his partner Victor F. von Lossberg and his grandson Edward Caldwell, continued manufacturing for several decades.

GRAND LOBBY CHANDELIERS

Edward F. Caldwell & Co. of New York City
(1895–1951)

Installed
1932

Media
Glass and metal

Dimensions
29 feet long

Location
Grand lobby

THE FOUNTAIN
OF YOUTH

Ezra A. Winter
(1886–1949)

Installed
October 1932

Type
Mural

Measurements
40 feet high, 60 feet wide

Medium
Oil paint on canvas

Location
Main staircase
from grand foyer
to first mezzanine

An enormous mural titled *The Fountain of Youth* sweeps up the staircase and overlooks the enormous grand foyer, a spectacular space created by the architect Edward Durrell Stone. The mural was one of the first commissions for the Music Hall and was arranged before the interior designer Donald Deskey was hired. It is reported that he disliked the mural and attempted to distance himself from any association with it. The mural depicts a legend from the Oregon Indians about the beginning of time when the world was new: "On a high mountain, which was built by birds, and beside the fountain of eternal youth, dwelt the Author of Life. Evil spirits also existed in the world and were enraged by such beauty, tranquility and everlasting youth. They caused an earthquake and a deep chasm to open, forever separating the miraculous mountain from the earth and its people." The artist portrays an old man nearing the end of his life and seeking a path up the mountain to the fountain of youth. He reaches a chasm and realizes the impossibility of crossing it to acquire eternal youth. As he wistfully gazes across the vast abyss, he perceives a ghostly parade infested with figures of humanity marching into oblivion. As the procession passes before him, he is confronted by his past ambition, pride, and vanity. He sees the flower of his youth terminating in the clouds of old age. Ezra Winter, an excellent colorist, used a distinctive palette of deep rich red for the background, dark lush green for foliage, and golden tones and swirling whites to evoke the dreamlike atmosphere. He used the huge, high, curving space equally well, creating depth and enveloping the viewer and suggesting a sense of spirituality. The mural was so enormous that it took Ezra Winter and his assistants working in an indoor tennis court over six months to paint it.

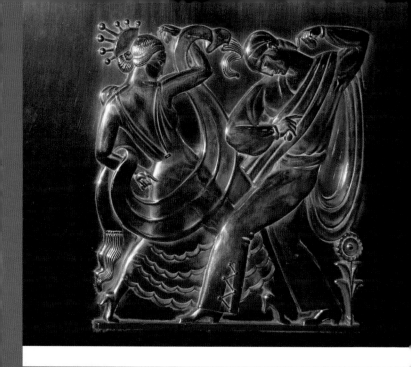

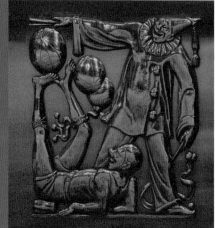

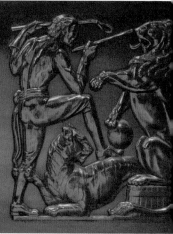

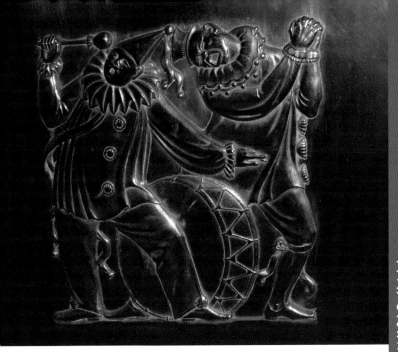

Deskey lost no opportunity to depict the activities of the theater and enhance the atmosphere. He commissioned Rene Chambellan to design bronze plaques for the doors that lead from the grand lobby to the auditorium. He created sixty-six low-relief plaques cast in highly polished golden bronze, representing scenes from vaudeville, stage, and old-time theater. These are installed on the massive brushed-stainless-steel doors. When the doors are closed, the plaques face the grand lobby and form a vast decorative wall of rich imagery. In dramatic fashion, the gleaming figures reverberate off the stainless-steel doors with a profusion of theatrical moments. Flying acrobats, fat ballooning clowns, vibrant dancers, jazzy musicians, brave lion tamers, snake charmers, and sassy fireeaters capture the essence of theater acts from around the world. These scenes open the doors to the soaring arches of the auditorium and the adventure of the theater. Oscar Bach, the famed metallurgist, was selected to oversee the casting and finishing of Chambellan's plaques.

**AUDITORIUM
DOOR PLAQUES**

Rene Paul Chambellan
(1893–1955)

Installed
1932

Type
Plaques

Medium
Cast bronze

Location
Auditorium doors

SINGING HEADS CARPET DESIGN

Donald Deskey
(1894–1989)

Type
Carpet design

Medium
Synthetic-fiber carpet

Location
Auditorium carpet

Donald Deskey embraced modern design in all its forms. He designed interiors, wall coverings, lamps, tables, chairs, and even Tide packages. *Singing Heads* is one of his classic Art Deco carpet designs. Each head has three undulating lines that create stylized hair. Stark semi-circular profiles stare straight ahead. Rectangular mouths are opened wide. The sound of song is symbolized by the same rising and falling lines that represent the hair. Small dots serve as eyes. Deskey set the heads in juxtaposition to each other, creating a bold composition of geometric patterns. The unusual color combination sets blue and off-white against a background of burnt orange. The carpet is vast, but not overwhelming. Its symbolism is perfect for a theater.

Ruth Reeves created a fabric design for the auditorium that depicts the myriad of activities that take place in the theater. She initially silk-screened the pattern on linen in her studio in small quantities. It was then commercially block-printed as many hundreds of yards of fabric were required for the walls. The color scheme is an audacious juxtaposition of deep red, pale pink, and off-white. It features a rhythmic pattern and a complex illustration of dancers, actors, musicians, horses, and vaudevillians floating and swirling in a splotchy background of colors. It surrounds the audience with symbols of the stellar entertainment to be found in the Music Hall. Creating a glitzy energy, it is typical of Reeves' designs, which unmistakably exemplify the Art Deco period. Reeves was a pioneer in fabric design and interested in ethnic fabrics. She spent the last years of her life working in India and collecting native fabrics and brasswork.

AUDITORIUM WALL COVERING

Ruth Reeves
(1892–1966)

Installed
1932

Type
Wall covering

Media
Block-printed fabric

Locations
Walls of the auditorium

GIRL AND GOOSE

Robert Laurent
(1890–1970)

Installed
1932

Type
Sculpture

Foundry
Roman Bronze Works,
Long Island City,
New York

Medium
Cast aluminum

Location
First mezzanine

This cast aluminum statue is one of the three naughty nudes that created quite a controversy when they were installed. It seems amazing that such a fuss could have been made over this graceful and reserved figure of a girl and a goose. The theme reflects the simple life. Laurent succeeded in taking a insignificant occasion and making it into a universal statement about man and nature. The girl's form is graceful and the goose is well sculpted. The piece is set against a tinted mirrored wall that augments the sculpture and gives the viewer another aspect of the piece by reflecting the back of the pale gray aluminum sculpture in warm tones of golden brown. Laurent catches a moment of lightheartedness and gentleness between the girl and the goose. This is clearly evident in the low placement of the girl's hands and the raised head of the goose. There is no conflict present; this is just a tender moment between the two figures that is sentimental and serene. The girl appears composed and seems to be tenderly quieting the bird. The subject matter is quite unique for a theater setting as it has nothing to do with stage business. By placing this piece and the works of Gwen Lux and William Zorach around the public spaces, Deskey hoped to offer people who may not go to museums an enriching cultural experience in an easygoing ambience.

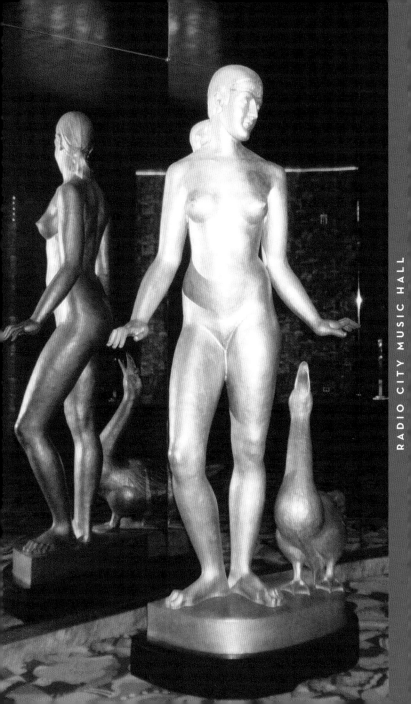

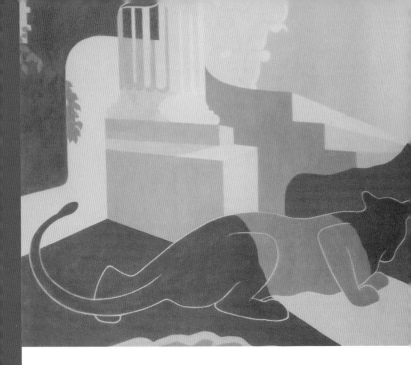

PANTHER MURAL

Henry Billings
(1901–1985)

Installed
1932

Type
Mural

Medium
Oil paint on canvas

Measurements
10 feet wide, 5 feet high

Location
Third floor ladies'
powder room

This mural is decorative, enigmatic, and powerful. There is no other work like it in the Music Hall and it is especially imposing in a room reserved for ladies. Stylistically, it moves away from Art Deco and toward Surrealism, where dreams and unreality were key themes. In this mural a crouching panther dominates the foreground. A shaft of light cuts across his body, and he appears to be stalking. His body is tense, his hind legs ready to spring, and his tail held high as if twitching with excitement. This cat is clearly a metaphor for power. His head is turned away from the viewer, drawing attention to the background, which is desolate. The solitude and isolation of this setting create an atmosphere charged with mystery. There is no real horizon, just a series of geometric shapes and a vast, empty sky. Bleakness dominates. A broken arch and a dead tree, traditional symbols of past civilizations, are strewn about. It is an eerie dreamworld.

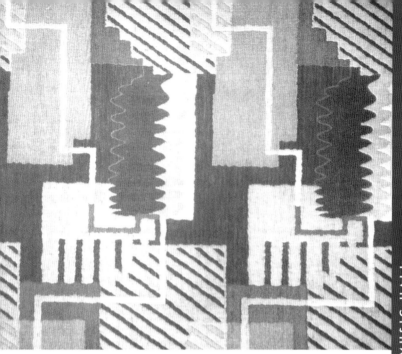

Taking advantage of the color palette found in the panther mural, and with his usual flare, Donald Deskey completed the interior design of the third-floor ladies' lounge. He created lamps, tables, and a built-in sofa; he skillfully incorporated Billings' beautiful colors in the design for the fabric wall covering. Its abstract pattern produces an eye-catching textile of remarkable vitality. It is the essence of Art Deco geometry with its parallel lines, overlapping images, comb edges, and angular meandering lines. Using the fabric to upholster the walls intensified the luxurious atmosphere of the lounge. The mural and Deskey's streamlined furnishings combined with this imaginative Deco textile were meant to impress and still do; this room remains one of the jewels of the Music Hall.

WALL COVERING

Donald Deskey
(1894–1989)

Installed
1932

Type
Wall covering

Medium
Fabric

Location
Third-floor ladies' lounge

EVE

Gwen Creighton Lux
(1908–2001)

Type
Sculpture

Installed
1932

Medium
Cast aluminum

Measurements
6 feet 6 inches high

Foundry
Roman Bronze Works,
Long Island City,
New York

Markings
Artist's monogram
and foundry

Location
First mezzanine near
Fiftieth Street staircase

The figure of *Eve* defies easy categorization. It certainly is not in the Art Deco style. Not everyone likes or understands this piece—many say it is ugly. It is an unflattering portrayal of woman and an unconventional portrait of *Eve*. Gwen Lux depicted her from an evolutionary view. She is not the time-honored lovely maiden in the Garden of Eden being enticed by the serpent to pick the forbidden fruit. She is a grotesque figure somewhere in the evolutionary process between an apelike being and a human being. That transformation is reflected in this roughly modeled and out-of-proportion creature. *Eve* is posed awkwardly with her head bent, legs bowed, knees apart, and her feet in contrary positions. A rudimentary drape clings to her legs as would a serpent. The object she fondles is the seed of life, symbolic of the future rather than the fruit symbolic of original sin. While Gwen Lux borrowed many elements of the biblical Eve, she challenges Genesis's account of her creation by offering this evolutionary view. Whether likable or not, the sculpture, given its heroic size and misshapen form, commands attention and is memorable. This sculpture was cast in aluminum because it was not only a modern lightweight metal, but it requires little maintenance and no patina. The sculpture is one of three female figures commissioned for the Music Hall by Donald Deskey, to be seen by the public in a congenial and relaxed setting. Shortly after installation, however, all three were removed for a time as they were deemed "licentious" by the famed impresario of the Music Hall, Roxy Rothafel.

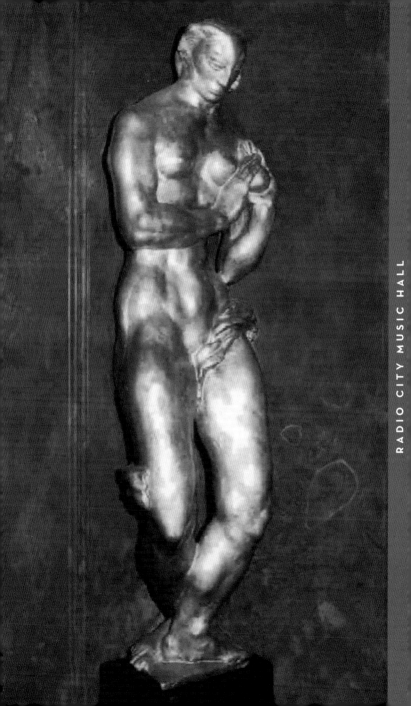

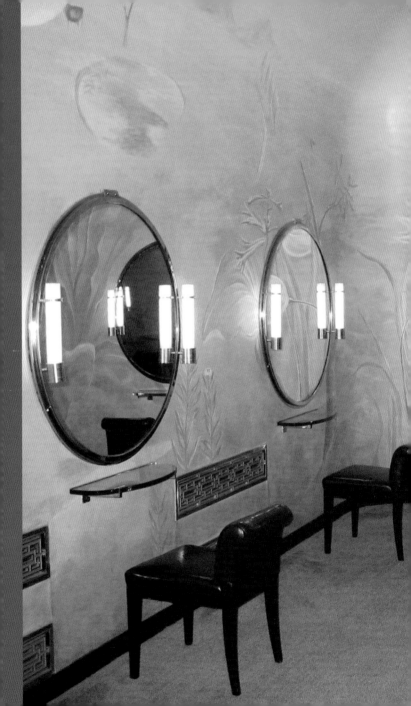

Donald Deskey attempted to commission Georgia O'Keeffe, the famed American painter, for a mural that would cover the walls of this room. She actually agreed to do the painting when her husband, the photographer Alfred Stieglitz, interfered, claiming that the pay for the commission was inadequate and would affect the price of future commissions. After a series of antagonistic events between the couple and Deskey, O'Keeffe suffered a nervous breakdown and the commission was awarded to Yasuo Kuniyoshi. Working with the theme of nature filling the space with beauty, he created one of the most delightful small rooms in the Music Hall. Combining the aesthetics of East and West, Kuniyoshi painted a luxuriant magical garden to decorate the walls. His painting totally covers the room, creating a scene without boundaries. Using the smooth, curving walls, he evoked his world of fantasy with delicately rendered larger-than-life botanical designs. They lithely sweep up from the floor, across the walls, and toward the rounded ceiling, creating an atmosphere of pleasure and beauty. Sinuous tendrils and gargantuan forms of plant life painted in subtropical tones evoke a dreamlike splendor. Soft tones are used to relax the viewer in this surreal world of dreams and fantasy. The motifs of lilies, palms, and other exotic plants executed in greens and white are set against an array of pale pink and blue hues. Kuniyoshi cleverly incorporated his designs into the architecture with leaves growing atop doors, flowers surrounding mirrors, and clouds enveloping the ceiling fixture. The motifs are organic, but the atmosphere and style are clearly Art Deco. This is enhanced by Donald Deskey's stylish modern furnishings and fixtures. The original work has suffered as a result of two restorations, one in the 1980s and the second in the late 1990s. Even with those heavy-handed restorations, the room retains the atmosphere of a secret garden paradise where only ladies are permitted to enter.

EXOTIC FLOWERS WALL DECORATIONS

Yasuo Kuniyoshi
(1893–1953)

Installed
1932

Type
Mural

Medium
Oil paint

Location
Second-mezzanine ladies' lounge

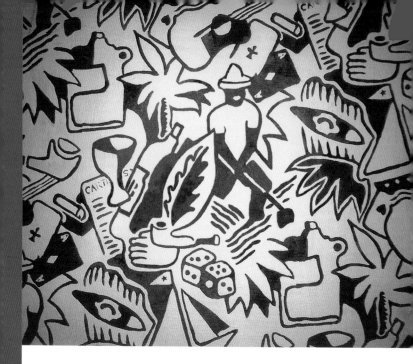

NICOTINE
WALL COVERING

Donald Deskey
(1894–1989)

Type
Wall covering

Media
Aluminum foil and paint

Location
Second-mezzanine
men's lounge

Donald Deskey created many of the Music Hall furnishings and interiors himself. He had a bold, futuristic vision of twentieth century design. He applied sleek, modern industrial materials to his creations. In 1932, the R. J. Reynolds Tobacco Company sought him out and asked him to design innovative applications for aluminum foil, one of its new products. Deskey was inspired by their primary product, tobacco, and created a design for a wall covering. The overall repeat motif was applied to the aluminum surface. The deep matte-brown pattern features a collection of stylized masculine themes: dice, pipes, tobacco leaves, sailboats, liquor bottles, farmworkers, and palm trees—reminiscent of the region where tobacco is grown. The result is lively and unique. It is also one of the best-known patterns in the Music Hall.

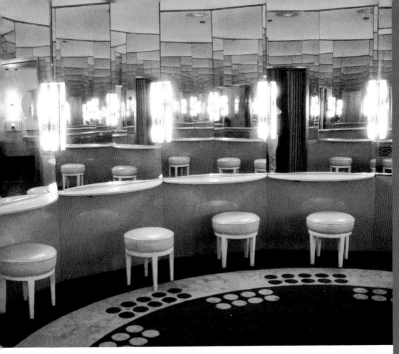

Deskey created the overall design and furnishings for a circular ladies' lounge. Light bounces across curved walls hung with sixteen angled mirrors and reflects the muted parchment colors of the ceiling and sleek, dainty furnishings. Set in the center of the room is a round carpet with a deep blue center and a white geometric border. An alternating pattern of white and blue dots flanks the edge where the blue and white colors meet. Deskey used long frosted sidelights set into the mirrors as decorative devices. The combination of low-key color, frosted lights, low leather-topped stools, circular carpet, and demilune wall-mounted shelves evokes a sense of beauty and fashion. In contrast to the deep, sober colors of the men's lounge, Deskey chose a soft, light palette, creating a genteel, elegant ambience. It is stylish and chic—and unreservedly Art Deco.

MIRROR ROOM INTERIOR DESIGN

Donald Deskey
(1894–1989)

Type
Furnishings and Interior design

Media
Wood, mirror, carpet, leather, paint

Location
First-mezzanine ladies' lounge

THE MAP
ROOM MURAL

Witold Gordon
(1898–1947)

Type
Murals

Installed
1932

Medium
Oil paint on canvas

Fabricator
Artist on-site

Location
First-mezzanine
men's lounge

Working from his series of small sketches, Witold Gordon created a large mural depicting the continents of America, Europe, Asia, and Africa on the lounge walls. It exemplifies a common American 1930s view of the rest of the world as an alien place. The images are exaggerated and imaginative. Gordon used disproportionate figures, caricatures of racial stereotypes, and many stock symbols that he scattered throughout the mural. The symbols associated with oceans are anchors, fish, and sailing ships. The Asian map is filled with structures such as mosques and temples and animals native to the continent, such as elephants and camels. Gordon labeled his geography with small signs. He used a palette of dark brown, warm yellows, reds, and gold against a predominant burnt-orange tone that was ideally suited to the masculine Art Deco furnishings Deskey had created.

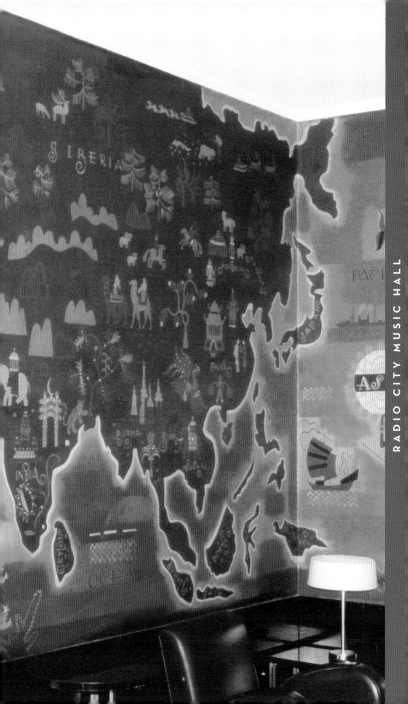

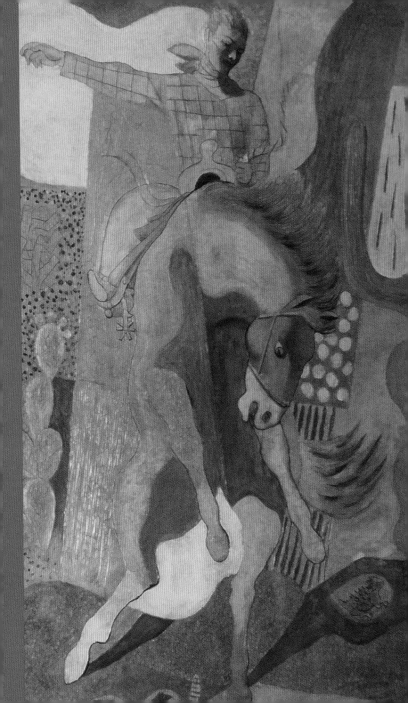

In the 1930s, Eduard Buk Ulreich was a well-known designer and muralist. Donald Deskey was aware of his unique style and commissioned this mural. Ulreich painted the mural on leather, a material that was also used by Deskey on the walls and in some of the furnishings found in the room. It is an unusual material to paint on and heightens the western feeling of the room. *Wild West* is a light-hearted mural. It is a stereotypical western scene symbolizing the vanishing American frontier. A cowboy is in the saddle, breaking a spirited bronco. The horse and rider are surrounded by images of the desert—succulent cacti, snakes, a gopher, and longhorns. As the horse rears in fright, the cowboy pulls the reins tight and flings his other arm out for balance. His Stetson goes flying. Curious longhorns regard the scene from the background and a gopher looks out from his burrow. The painting has the quality of a comic strip due to its whimsical animals and exaggerated humorous details. Stylistically, it cannot be considered Art Deco, although the furnishings surrounding it, designed by Deskey, are clearly in that style. The mural is an example of separate elements and blocks of color fragmenting the canvas and creating a playful sense of action, thrust, and speed. Ulreich's earthy palette reflects the western plains. He used sandy beige, gray, brown, green, and off-white with touches of red, and enhanced the surface by mixing sand into the paint to achieve a rough texture and suggest the harshness of the desert. It has remained in brilliant condition, testifying to the high degree of the artist's technical knowledge and ability.

WILD WEST MURAL

Eduard Buk Ulreich
(1889–1966)

Type
Mural

Subject
Early American West

Installed
1932

Media
Oil paint and
sand on leather

Fabricator
Artist

Measurements
6 feet square

Location
Third-mezzanine
men's lounge

DANCING FIGURE

William Zorach
(1887–1966)

Installed
1932

Type
Sculpture

Measurements
72 inches high

Foundry
Roman Bronze Works,
Long Island City,
New York

Medium
Cast aluminum

Location
Grand lounge

In the center of the main lounge is the over-life-size casting of a nude female figure resting on one knee, a scarf softly draped behind her. She is a study of the rounded, full shapes and simplified forms that characterize Zorach's work. In this sculpture, the concept of dance, or movement, is minimally rendered. Even so, the form effortlessly conveys gesture and implies motion. It is an oversize figure and yet the scale does not diminish the gracefulness of the piece. Her face is alert and watchful, as if she is waiting for a signal to rise and commence a slow, floating dance, or perhaps she has just finished and is taking a bow. The figure was created at the same time as the works of Gwen Lux and Robert Laurent and was cast at the same foundry. Archival photos show the three artists working side by side. All three sculptures are nude figures and were commissioned by Donald Deskey for the Music Hall. Being a modernist and an advocate of industrial materials, he ordered the sculptures cast in aluminum. As an artistic casting material, aluminum was an unusual choice at the time and remains so today. The light color of aluminum combined with the softness and low-reflective qualities of the surface provide a distinct effect to the sculptures that would not have been found in a more traditional metal such as bronze. It is also a lightweight metal that does not corrode or require any patina or protective coating. The dancing figure is one of the three sculptures removed from view by Roxy Rothafel, the impresario of Radio City. The sculptures were reinstalled following a public outcry, as their nudity was not deemed scandalous or unfit for a public theater.

Witold Gordon created a second mural for the largest lounge in the Music Hall. The mural is a series of Arcadian scenes of poised, fashionable women in classic surroundings. They are immersed in a rosy life of glamour and focused on their beauty. The ladies are blissful and graceful—and totally self-indulgent. The vignettes are painted in an elegant, traditional style. The mood is romantic, tender, and sets an intimate tone to the lounge. Gordon's palette of dainty colors—pinks, blues, and ivories—creates a feminine aura with luxurious garments and sumptuous surroundings. Deskey designed the Art Deco furnishings for the lounges. In what appears to be a whimsical gesture, he included a chaise-lounge for any lady who might have felt faint.

HISTORY OF COSMETICS MURAL

Witold Gordon
(1898–1947)

Type
Mural

Installed
1932

Medium
Oil paint on canvas

Fabricator
Artist on-site

Location
Ladies' lounge off
the main lounge

THE PHANTASMAGORIA OF THE THEATER

Louis Bouche
(1986–1969)

Type
Murals

Subject
Five vignettes
of theater scenes

Installed
1932

Medium
Oil paint on Pyroxalin

Location
Walls of the main lounge

Donald Deskey commissioned Louis Bouche to paint a series of vignettes representing various theatrical scenes for the walls of the main lounge. Bouche chose five eras in which to focus his lively narrative. He was historically liberal, mingling various epochs in single scenes. Views of the early Italian stage were combined with characters from the contemporary stage. Bouche portrayed early Greek tragedy with modern drama. As an inspiration for one of his most amusing vignettes, he used the vaudeville team of Joe Weber and Lew Fields. At that time, Weber and Fields were quite elderly but still famous for their popular comedic skits and actually posed for Bouche. Collectively, the vignettes are self-importantly titled *The Phantasmagoria of the Theater*. Phantasmagoria was a magic lantern show (early slide show), with optical illusions that made objects materialize, disappear, change size, and merge. The vignettes are painted in Bouche's academic style. The colors are bright and the illustrationlike compositions skillfully arranged. The scenes are painted on specially prepared, pyroxylin-coated black walls. This stark black background draws attention to the paintings, making them stand out from the dark wall. Bouche's work is not earthshaking, but in Deskey's eclectic setting, the vignettes are charming and suitable for a theatrical lounge of the 1930s. Bouche was versatile, ambitious, and hardworking not only as a muralist, but as an easel painter. This is the only work he created for the Center.

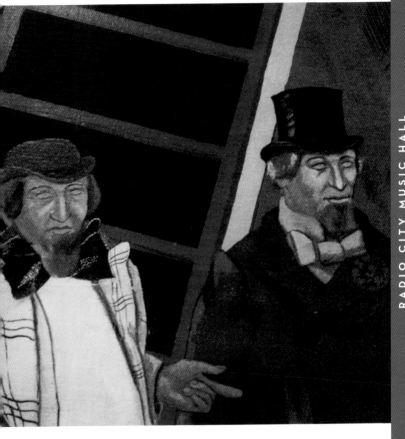

This stunning mural contains no human figures, although its original title was *Men Without Women*. It is rumored that the title was given to it by a Rockefeller Center committee and perhaps based on a short story by Ernest Hemingway. Apparently, Stuart Davis did not think the title appropriate and in 1975 when the mural was gifted to the Museum of Modern Art, it was retitled simply *Mural*. In 1999, after an extensive renovation of the Music Hall, the museum lent it back without a title. The subject is a passé vision of masculine recreation and activities that were popular in the 1930s. It contains images suggestive of what men allegedly enjoyed in their leisure time: a roadster, a pipe, a gasoline pump, a pack of cigarettes, cigars, a tobacco pouch, playing cards, a horse, a sailboat, matches, and barber poles are strewn across the surface. It was the first painting made by Davis in such a large format. At first, Davis and Deskey planned the mural in cutout linoleum, another modern material. This limited medium had dictated the color scheme and the blocklike shapes of the mural. The idea of linoleum was abandoned and the mural completed in traditional oil paints on canvas. The bold colors are flat and hard, without shading or texture. A few areas are striped or patterned. The shapes are solid, interlocking forms set one against the other. There is no true perspective, no foreground versus background. There is only a single flat plane, but the painting vibrates in the stylized, jazzy, push-pull manner of Cubism.

UNTITLED MURAL

Stuart Davis
(1894–1964)

Installed
1932 (removed 1975)
reinstalled 1999
(on loan from MoMA)

Type
Mural

Measurements
10 feet 8 inches high,
17 feet 1 inch wide

Medium
Oil paint on canvas

Location
Men's lounge off
the grand lounge

EXTERIOR ELEVATOR DOOR PANELS

Rene Paul Chambellan
(1893–1955)

Installed
1932

Type
Low-relief panels

Measurements
Approximately 2 feet high

Medium
Cast stainless steel

Location
Exterior of elevator doors

Working with the famed Music Hall impresario S. L. "Roxy" Rothafel, Donald Deskey was aware that every small detail and decorative element was important in creating the right atmosphere for the Music Hall. Both saw the theater as a place people come to escape their dreary lives and spend time in a pleasure palace—an elaborate world of fantasy. With its rich imagery, luxurious surroundings, and attention to detail, Radio City Music Hall was intended to be the greatest of all pleasure palaces. The highly talented artist and proficient technician Rene Chambellan was commissioned by Donald Deskey to provide designs for the elevator doors. In this instance, the designs were placed in panels on the elevator's exterior doors as low-relief castings of classically dressed figures. The compact compositions fill the spaces and are innovative representations of musicians: a flutist, cymbalist, violinist, etc.

The circular designs found on the wood-paneled interiors of the elevator cabs are attributed to Edward Trumbull. They are the only specific designs he is credited with creating anywhere in Rockefeller Center. In spite of being a well-known and widely recognized muralist, he was primarily employed at the Center as a consultant. He recommended color schemes and harmonized materials as well as coordinated the work of other artists in the interior of buildings. Setting aside the issue of provenance, the elevator cab panels are stunning and an effective use of mundane spaces. The rondels are delicate inlays of exotic woods, steel, Bakelite, and aluminum set in the centers of the elevator cab walls. Each elevator has three rondels. The themes are wine, women, and song in classic settings and dress. The animated scenes are illustrations of prancing satyrs, lively musicians, and dancing maidens, all escaping the woes of life. The variety of Trumbull's designs and materials enhance the spaces and subtly adds to the adventure of the theater.

ELEVATOR RONDELS

Edward Trumbull
(1884–1968)

Installed
1932

Type
Rondels

Measurements
Approximately
3 feet in diameter

Media
Inlaid woods,
Bakelite, metal

Location
Elevator cab walls

TEXTILE WALL COVERING and CARPET DESIGN

Marguerita Mergentime
(unknown–1941)

Installed
1932

Type
Wall covering and carpet

Media
Damask and
synthetic-fiber carpet

Locations
Wall covering: third-
mezzanine ladies' lounge.
Carpet: grand lounge
near elevators

Marguerita Mergentime was an industrial textile designer whom Deskey commissioned to produce both a fabric motif for a wall covering and a rug pattern. The designs are quite different and found in two separate areas. Stylistically, Mergentime cannot be considered a strict Modernist as much of her work retains traditional forms and natural, organic motifs such as flowers. It synthesizes different eras and yet distinctly reflects aspects of American Modernism through its use of abstract forms and color. In the wall fabric for the ladies' lounge, Mergentime used a repeat pattern of a floral motif, a softly colored design of lilies, leaves, and other forms found in nature. The design is barely perceptible—it is a muted, subtle pattern rendered in the palest of hues. The fabric hanging there today is a replica developed from a black-and-white photograph and a description of the fabric found in a newspaper article of the time. In contrast to the fabric, Mergentime's lively carpet is closer to American modernism with its geometric background pattern and palette of blue and light brown hues superimposed with black line drawings. The animated drawings are reminiscent of Ruth Reeves' rug design in the grand foyer. It, too, is all about theater. Musicians, ballerinas, dancers, clowns, acrobats, prancing horses, and dancing dogs are strewn across the abstract background pattern.

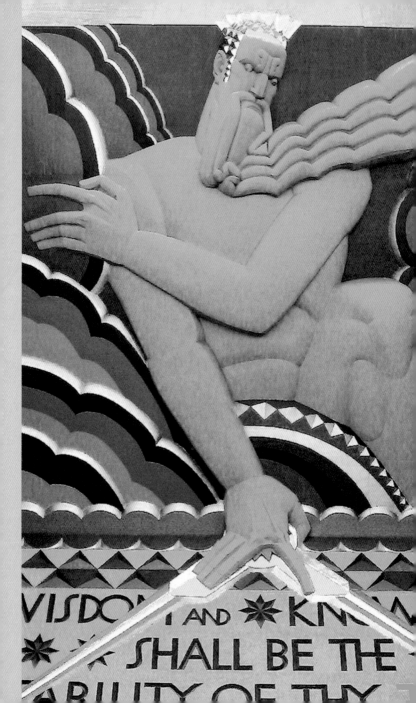

VISDOM AND ✷ KNOW
✷ ✷ SHALL BE THE
ABILITY OF THY

Lee Lawrie employed a number of materials and artistic devices to create a sculpture that would be a focal point and one of the most imposing pieces in the Center. The daunting figure of *Wisdom* looms over the entrance to the main building of Rockefeller Center—it can be seen from Fifth Avenue. Lawrie used height, mass, color, gilding, and two very different materials—stone and glass—to create it. He set the angular figure at a slant, thrusting it toward the viewer. The figure rises out of vast, swelling clouds that surge around his naked body. *Wisdom* is commanding and awesome. His brow is furrowed and his expression intimidating. Golden rays crown his head. His left hand shoves away the billowing clouds of ignorance which might obscure wisdom and his right arm cuts diagonally across the panel. The right hand stretches downward, holding a fully extended golden compass that measures the cosmic forces swirling in the glittering glass screen below. *Wisdom*'s long beard, a symbol of sages, soars upward, indicating the strength of the forces seeking to impact and surround him. The biblical words "Wisdom and Knowledge Shall Be the Stability of Thy Times" (Isaiah 33:6) are highlighted. These words are a reminder and admonition to man that he *will* be measured by a higher power. *Wisdom*, the creative power of the universe, controls man's activities first by masterminding them, and then by appraising them. This massive work provides drama and focus to the building and is flanked by two other sculptures symbolizing the cosmic forces of the universe: *Sound* and *Light*. *Wisdom* was the first exterior piece in the Center to be painted and gilded. The coloration was created by Leon V. Solon in collaboration with the artist. Their joint efforts created an Art Deco icon.

WISDOM

Lee Lawrie
(1877–1963)

Installed
1933

Type
Low-relief panel

Media
Carved Indiana limestone, cast glass, polychrome paint, gilding

Fabricator
Piccirilli Brothers and Corning Glass Works, Corning, New York

Measurements
Stone: 22 feet high, 14 feet wide
Glass: 15 feet high, 55 feet wide
Total height: 37 feet

Location
Above main entrance

SOUND and LIGHT

Lee Lawrie
(1877–1963)

Installed
1933

Type
Low-relief panels

Media
Carved Indiana limestone, cast glass, polychrome paint, gilding

Fabricator
Piccirilli Brothers

Measurements
Sound: 5 feet high
Light: 5 feet high

Location
Above main entrance

Sound and *Light* symbolize two of the cosmic forces derived from *Wisdom*. From the viewer's perspective, *Sound* is located to the left of *Wisdom*. Combined with *Light*, which is located on *Wisdom*'s right side, a monumental sculptural group is formed that is thematically united. The sculptures are placed above a glass screen that is also an integral part of the complex design. Both *Sound* and *Light* are depicted flying out of clouds toward the viewer and away from *Wisdom*, extending the central decoration across the whole entrance. They are heralding the advent of radio (sound) and the motion picture industry and television (light), industries that were just achieving global importance at the time the Center was being built. Lawrie's figures are bold, streamlined, angular Art Deco carvings. Leon V. Solon made them stronger by coating them with vibrant, jazzy colors. *Sound* is animated and alert like a man on a mission. He is young, muscular, and energized. His hands are cupped around his mouth as he shouts to the passersby below. Circles emanate from his mouth, symbolizing his voice—the sounds of radio. *Light* also emerges from vivid cosmic clouds. She has raised her arms above her head, which then disappear into infinity. Multicolored rays radiate and shimmer about her. *Light*'s hair, composed of sharp zigzag lines of black and gold, dramatically shoots upward, adding to the effect of energy erupting in bursts of light rays. *Light* is sending electrical images through the air for the people of the world to view. *Sound* and *Light* are two of the Center's most exhilarating Art Deco architectural embellishments.

AMERICAN PROGRESS

José María Sert
(1876–1945)

Installed
December 1937

Type
Mural

Medium
Oil paint on canvas

Measurements
41 feet long,
16 feet 7 inches high

Location
Main lobby

José María Sert was commissioned to paint this mural following the controversial destruction of Diego Rivera's fresco that had originally occupied the main lobby's wall. Rivera had surprised and offended the Rockefellers by including a portrait of Lenin as a principal figure in his fresco. The Rockefellers felt this was an assault on capitalism and everything they championed. They fired Rivera and destroyed his work. Over the next two years, ideas for the empty space were considered and reconsidered. In frustration, the architects dubbed it "the Wailing Wall." Eventually Sert was approached, because he had already painted a number of murals for this building and was reliable and talented. He submitted a detailed oil sketch and was commissioned. The resulting mural is the focal point of the lobby. It depicts the development of America through the unity of brain and brawn. On the right, looking upward, are three Graces: Poetry, Music, and Dance. The three Graces are symbolic of man's intellectual activity: his dreams, ideals, and creativity. On the left, looking earthward, are Titans and men working, representing men of action: builders, inventors, and laborers. In the center, the artist has painted two great Americans. Wearing a top hat, Abraham Lincoln represents men of action. He rests his hand on the shoulder of Ralph Waldo Emerson, seated, who personifies great philosophers and thinkers. In the background rise the skyscrapers of Rockefeller Center, symbolic of man's great achievements through the unity of brains and brawn. Sert had been directed to "draw" the scenes on "toned" canvas and limit the coloration. He advanced the concept by using only stony colors and employing techniques for which he was well known. He dragged rags across the surface, used his fingers, and dabbed brushes to achieve this complex and sumptuous mural.

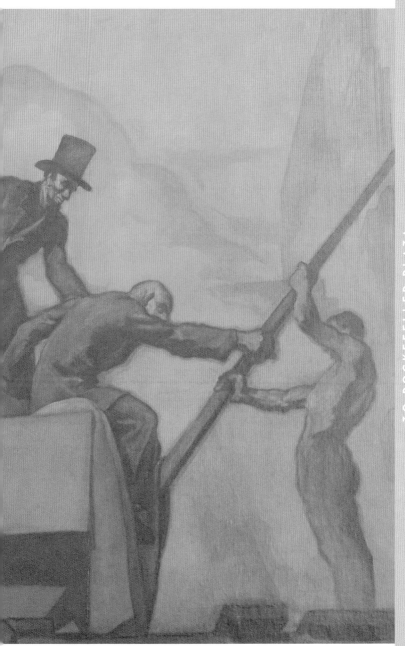

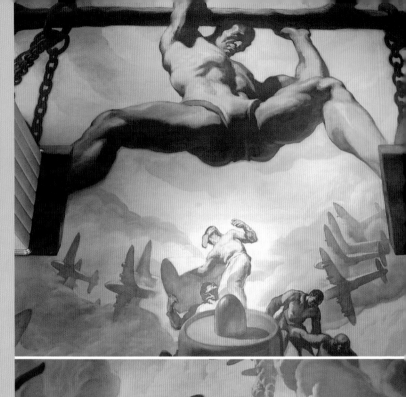

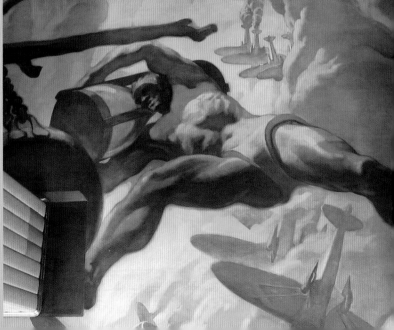

The passage of time is the means by which mankind measures his accomplishments and sets goals for the future. In this dramatic ceiling mural, Sert painted heroic-sized, nearly naked Titans symbolizing the three aspects of time: *Past, Present,* and *Future.* By exposing their bodies, Sert implies that time is part of nature, and by making them muscular he implies time is powerful. The Titans are portrayed evaluating man's achievements. This judgment is symbolized by a huge scale built of a massive log and heavy chains. The mural integrates the architecture into the subject matter. Both the scales and the Titans' feet are shown resting on actual marble columns that support the lobby ceiling, creating a splendid panoramic vision of the weighing of man's deeds. *Past* and *Future* hold hourglasses representing elapsed and future time containing the measurement of man's performance. These deeds are being deposited on the evenly balanced scales of *Present.* At the eastern edge of the ceiling, men are depicted working on airplanes symbolizing man's creation of tools and machines—and their usefulness to mankind. In the background, a fleet of aircraft is used to represent man's exploration of time and space, both infinite aspects of the universe. Aircraft circle the skies, their smoke creating a vortex that draws the viewer in toward the future and the unknown. The mural is 45 feet above the floor and remarkable for its drama and unique perspective. As one walks slowly across the lobby, gazing upward at the mural, the figure of *Present* appears to move away from *Past* and toward *Future.* The awesome size of the magnificent figures balanced on marble columns and the limited palette of stony colors import depth and energize the vast ceiling. *Time* was the final mural José María Sert painted for Rockefeller Center—it is audacious and opulent.

TIME

José María Sert
(1876–1945)

Installed
March 1941

Type
Mural

Medium
Oil paint on canvas

Measurements
5,000 square feet

Location
Ceiling of main lobby

30 ROCKEFELLER PLAZA

SPIRIT OF DANCE

José María Sert
(1876–1945)

Installed
March 1941

Type
Mural

Medium
Oil paint on canvas

Measurements
25 feet high, 17 feet wide

Location
North hall

José María Sert's submission for the main-lobby mural, *American Progress*, did not wrap the corners of the wall as had Rivera's fresco. He was asked to provide two additional murals for these walls. The north mural, *Spirit of Dance*, expresses joy and release from the problems of the world. Its symbolism is a little arcane. The large central figures are tied together with a heavy rope. The rope symbolizes mankind being tied to the problems of the everyday world. Six other figures have built a scaffold from which they are hanging or reaching out toward the large figures to release them from their bonds. One figure is hanging off a beam and has a noose in his left hand which he has just removed from the central figures. The slack noose represents release from day-to-day troubles. The central figures are blissfully dancing as their restraints fall away.

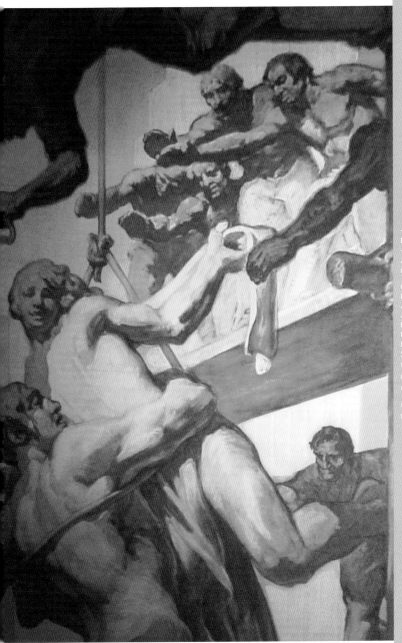

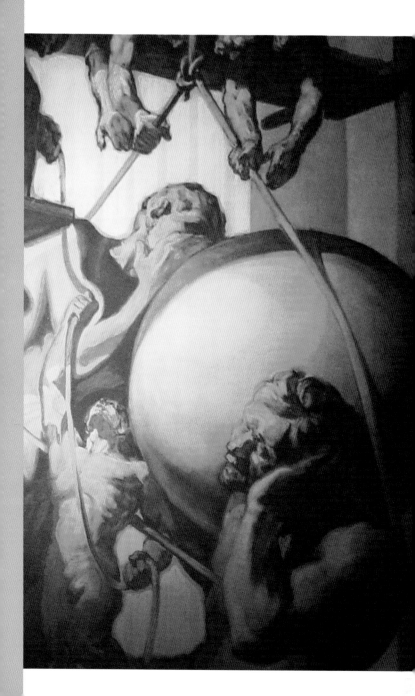

This mural also contains a scaffold, ropes, and human-size figures reaching toward larger figures—gods who flank a globe. One speaks into the globe while the other receives his words. The smaller figures represent mankind and are hoisting the gods and their globe upward. The figure standing on the leg of one of the gods is directing their action. His position suggests he has triumphed over the god. The message of this mural is that mankind has learned from the gods how to communicate or, perhaps, stolen that power from them. The six men are making a communal effort by using ropes and aggressively pulling to advance man's ability to communicate. The reference in this mural is to newly developed means of communication—radio, telephone, and telegraph.

MAN'S TRIUMPH IN COMMUNICATION

José María Sert
(1876–1945)

Installed
December 1937

Type
Mural

Medium
Oil paint on canvas

Measurements
25 feet high, 17 feet wide

Location
South hall

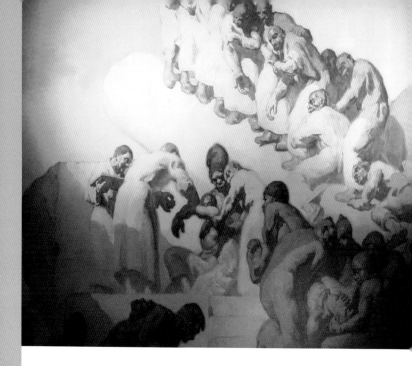

CONQUEST
OF DISEASE

José María Sert
(1876–1945)

Installed
1933

Type
Murals

Medium
Oil paint on canvas

Measurements
Each mural 25 feet high,
17 feet wide

Location
North corridor

The first commission José María Sert received for Rock-efeller Center was to paint four murals to decorate the ends of the elevator banks. Rockefeller's art committee dictated their themes. The overall theme was: "These will explain man's new mastery of the material universe." The four subthemes were: "(1) His Power (2) His Will (3) His Imagination (4) His Genius." Sert was to interpret these guidelines in his unique style and from his own perspective but with a limited, neutral palette. From east to west the first mural is: *Powers That Conserve Life*. In this work he portrays the development of industrial tech-nology and the eradication of painful labor by the ma-chine. A massive locomotive steams forth. Laborers and horses are seen pulling a gigantic gear, symbolic of the mechanization of industry and freedom from manual la-bor. His second mural, *Conquest of Disease* deals with the development of modern medicine, especially the concept of inoculations. At this time many people were fearful of live virus injections to prevent smallpox. This mural depicts doctors inoculating lines of people.

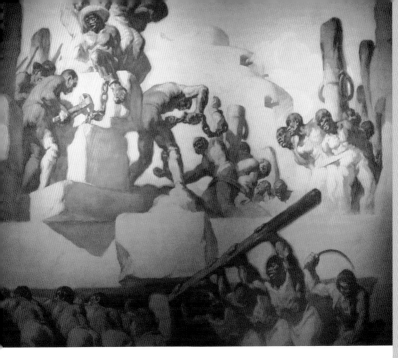

The third mural, *Abolition of Bondage*, is a commentary on slavery, which at the time was still to be found worldwide. He depicts slaves toiling or bound to stakes. Others are being freed, their shackles broken. The fourth mural, *Abolition of War*, expresses the elation people feel at the end of a war. Sert shows a mother ecstatically raising her child above her head while she stands on a broken cannon, a symbol of the end of war. Below, women joyfully rush toward their returning men. In each of his powerful canvases Sert has portrayed people conquering life's cruel realities and inequities. His murals radiate drama and an unwavering belief in mankind.

ABOLITION OF BONDAGE

José María Sert
(1876–1945)

Installed
1933

Type
Murals

Medium
Oil paint on canvas

Measurements
Each mural 25 feet high,
17 feet wide

Location
North corridor

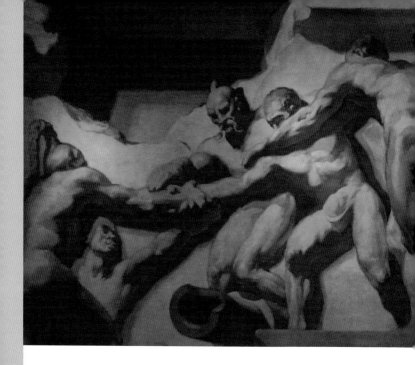

FRATERNITY OF MEN

José María Sert
(1876–1945)

Installed
December 1937

Type
Mural

Medium
Oil paint on canvas

Location
North stairway
in the grand lobby

In this mural, Sert has depicted the resolution of the problems of the world. The five races of the world are shown leaning toward one another clasping hands in brotherhood. The mood is powerful. The men are nearly nude, demonstrating their openness and indicating peace can be ingenuous. A broken cannon and shattered walls, symbols of destruction, are strewn about—these are the stuff of the past. The heroic figures represent mankind's strength and the possibility of universal peace. It is an optimistic view, painted at a time when Europe was on the verge of war. Sert was a prolific muralist who throughout his work portrayed the idealized figure. His palette is always a combination of neutral tones and his painting technique unique to his atelier.

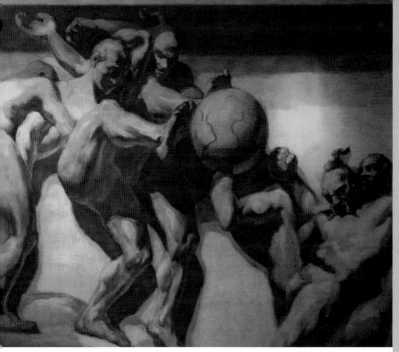

In this mural, Sert presented a far more pessimistic view of the world than in *Fraternity of Men*, which was painted three years earlier. Within those years, he saw Europe at war and the world as having given up on the idea of international peace. This unpleasant scene starkly symbolizes this sad period. He used the same theme of the five races of mankind as found in *Fraternity of Men*. This time they are kicking the world around as if they were playing a game of football. He depicts the men as focused, angry, and intent on winning. The background is empty, insinuating that war creates nothing— no achievements or successes for mankind. It is interesting that the Rockefellers chose to present these contrasting murals and views of the mankind just prior to America entering the war.

CONTEST–1940

José María Sert
(1876–1945)

Installed
December 1940

Type
Mural

Medium
Oil paint on canvas

Location
South stairway
in the grand lobby

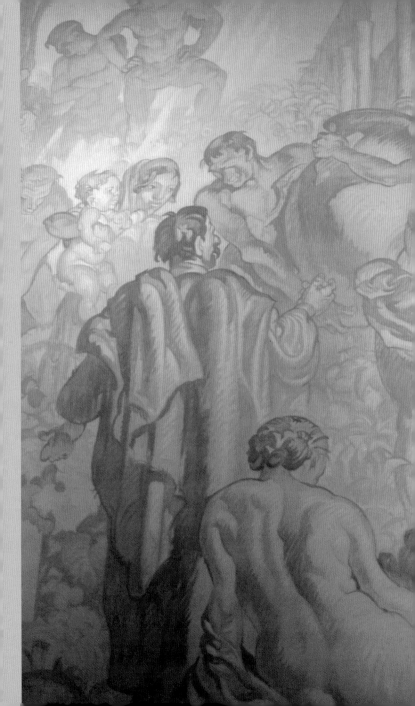

Sir Frank Brangwyn's four South Corridor murals were to complement the murals by José María Sert in the north corridor. Edward Trumbull, the coordinator and supervisor of the murals project, had hoped for an aesthetic relationship between these artists' works by requiring the two to constrict both their palettes and their techniques so that their murals would be as close to "drawings on toned canvas" as possible. Most observers agree that this aesthetic bond was never achieved. Brangwyn was internationally famous, and owing to that reputation and the enormous size of the murals, was granted use of the Royal Pavilion at Brighton, England, as a studio. Many local people from his hometown, Ditchling, were used as models for this series—even the dog. The overall theme is man's search for eternal truth through Christ's teachings. The first three murals represent three stages in man's conquest of the physical world. The fourth implies the essence of his destiny. Each mural bears an inscription which clarifies the scene. The first portrays the beginning of civilization and begins, "Man laboring painfully with his own hands. . . ." The second illustrates the dawn of agriculture and begins, "Man the creator and master of the tool. . . ." The third mural deals with the development of the machine age and begins, "Man the master and servant of the machine. . . ." The fourth mural is concerned with man's fate and spirituality, evoking the Sermon on the Mount. It begins, "Man's ultimate destiny depends on whether he can learn new lessons. . . ." This last mural caused some concern among the builders, who felt that his inclusion of a Christlike figure might not be appropriate in a commercial building. In response, Brangwyn toned down the figure to a vague hooded shape standing above the crowd. Brangwyn's murals reflect not only the development of civilization but the Rockefellers' deep belief in man and his spirituality.

BRANGWYN'S SOUTH CORRIDOR MURALS

Sir Frank Brangwyn
(1867–1956)

Installed
1934

Type
Murals

Medium
Oil paint on canvas

Measurements
25 feet high, 17 feet wide

Location
South corridor
of main lobby

RADIO

Leo Friedlander
(1890–1966)

Installed
1934

Type
Heroic-scale sculpture

Medium
Carved limestone

Measurements
15 feet high, 10 feet wide

Location
Fiftieth Street entrance

Although *Radio* and *Television* are located on different streets, they are companion pieces. They are associated thematically with the building's main tenant, NBC. Each flanks a side entrance to the building, one on Forty-ninth Street and the other on Fiftieth Street. Their overall scale is heroic and their forms daunting. Leo Friedlander's symbolism does not make his sculptures easy to understand—both sculptures are visual puzzles that need to be deciphered. In these works, size, mass, texture, and repetition play important aesthetic roles. Size and mass are used to awe the viewer and lend strength to the architecture. Texture and repetition lend interest to the carvings. *Radio* is a cryptic association of various elements. The group on the east pylon represents broadcasting. Three figures sing to the larger figure (transmission), who sends the sound to the west pylon, to the figures representing acoustics. The figures of Mother Earth and her child in the foreground represent the people of the world (the audience) receiving the sounds of radio.

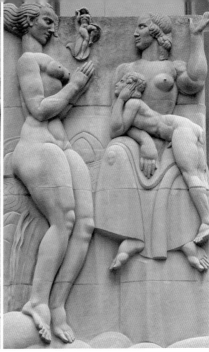

The work *Television* is just as perplexing as *Radio* to most viewers. Again, the most important concept is transmission, this time pictorially. The figures on the west pylon with their left legs lifted are dancing. That image is being transmitted by the larger figure who looks down at her hands, which frame the invisible picture of dancing figures. That transmission is sent to the east pylon. On this pylon, we find the standing figure of reception presenting a small image of the dancing figures to the audience, which is represented by the seated figures. *Radio* and *Television* are architectural icons of Art Deco architectural sculpture.

TELEVISION

Leo Friedlander
(1890–1966)

Installed
1934

Type
Heroic-scale sculpture

Medium
Carved limestone

Measurements
15 feet high, 10 feet wide

Location
Forty-ninth Street
entrance

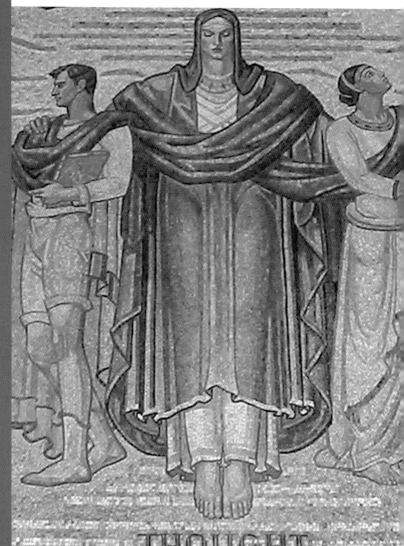

THOUGHT

This colorful mosaic is often missed as it is installed within a loggia, above the entrances to the building. A masterwork of small glass tiles (tesserae) set in white cement, it was fabricated in a workshop in Long Island City and is composed of over one million glass tiles in two hundred and fifty colors. Each small glass tile was hand-cut and hand-set. The work is a narrative concerning the triumph of knowledge over the evil of ignorance. The central figure symbolizes thought (intelligence). She stands above the world and controls the action in the mosaic. Flanking thought are the other two most powerful figures in the mosaic: spoken words and written words. From these central protagonists float other figures symbolizing creativity, ideas, and intellectual efforts. Emanating from these figures are the subjects that enlighten and advance civilization—science, biology, music, and art. Accomplishments in these fields are conveyed and broadcast on the wings of radio. Originating from behind the central figure is a golden current of thought energy in the form of radiating waves of knowledge. Knowledge is a powerful force that devours the enemies of mankind: ignorance, cruelty, poverty, and fear. The mosaic's message is clear: thought will propagate new knowledge and dispose of human misery and ignorance, thereby advancing civilization. The work has a religious tone, as mosaics are most frequently found in churches. The choice of material was quite deliberate as the theme was meant to inspire awe and celebrate ethical man as well as embody the Rockefellers' fervent belief in education and the spread of knowledge. The artist had originally titled the work *Thought Frees Man Through Radio* because it was to be installed on the façade of the newly built RCA Building.

INTELLIGENCE AWAKENING MANKIND

Barry Faulkner
(1881–1966)

Installed
1933

Type
Mosaic

Fabricator
Ravenna Mosaic Works,
Long Island City,
New York

Medium
Glass tesserae

Measurements
79 feet long, 14 feet high

Location
1250 Avenue of
the Americas loggia

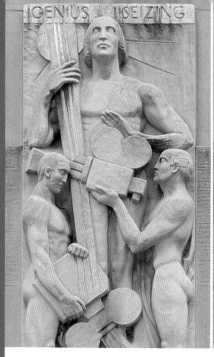

ASPECTS OF MANKIND

Gaston Lachaise
(1882–1935)

Installed
1935

Type
Bas-reliefs

Medium
Indiana limestone

Measurements
Each panel
11 feet 4 inches high,
4 feet wide

Location
1250 Avenue
of the Americas
sixth-floor façade

High on the façade of the building are four stone carvings by the French-born American sculptor Gaston Lachaise. It is quite remarkable that he was commissioned to create any artwork for Rockefeller Center because he had a reputation for sculpting robust, sexually explicit nude women. The erotic energy of his work was not lost on the art critics and collectors of the time, who for the most part shunned his aesthetic. His work at Rockefeller Center was a result of Nelson and Abby Rockefeller's patronage. Both were supporters of avant-garde artists and avid collectors of his work. Abby helped establish the Museum of Modern Art. Unfortunately, fame came late to Lachaise and he died early. In this allegorical work, he expresses four ideal and lofty aspects of the development of modern civilization: *Genius Seizing the Light of the Sun* (the development of electricity and communications), *The Conquest of Space* and *Gifts of Earth to Mankind* (an acknowledgment of spirituality), and *The Spirit of Progress* (a reference to the bond between capitalism and the unions during the building of the Center). The artist used two scales for

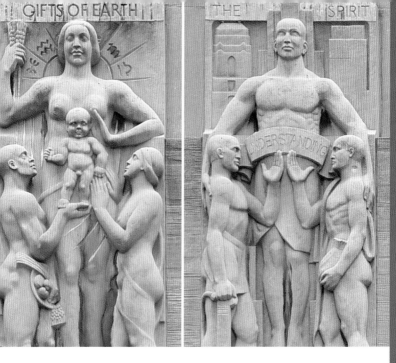

UNDERSTANDING

the figures—human activity is represented by slightly larger-than-life-size figures, and spiritual activity is represented by heroic-sized figures. The panels glorify man as he harnesses nature's powers for the advancement of civilization. They were carved in Indiana limestone at Lachaise's studio and sharpened up on-site after installation. As a consequence of working under the guidance of a very domineering art committee, the panels cannot be considered among Lachaise's best sculptures. The members of the committee insisted on changes and modifications every step of the way. At one point, Lachaise was asked to modify his work almost completely. He complied with each request. As a result, the bas-reliefs have the "aroma" of a committee about them.

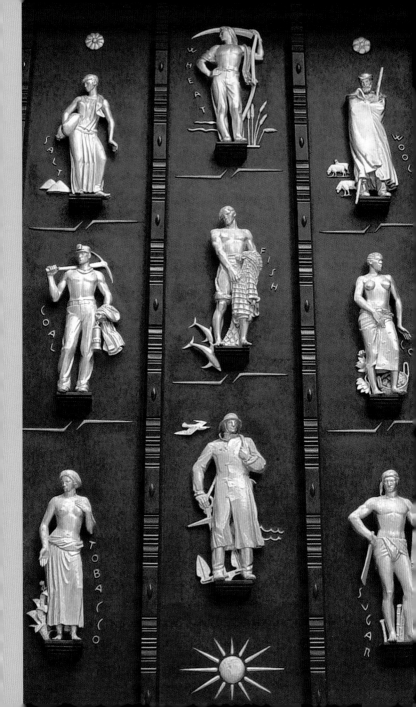

Industries of the British Empire is a large bronze panel embellished with gilded allegorical figures. It is an austere panel that is striking without being ostentatious. The broad, stark surface of the background emphasizes the classically rendered and carefully organized group of nine figures in three vertical rows. These figures are representatives of industries, not portraits of individuals. The various industries were found throughout the empire and were once major sources of income for the British. There is nothing insignificant about the figures' presence because their fixed frontal poses and firm stances embody substance and confidence. The gleaming figures are set against a rich brown patina. Their gilding underscores the concept of immeasurable wealth. In spite of their tasks, none of the figures appears burdened. They are depicted as beautiful, unemotional, and idealized—serving the glory of the empire. Eight of the figures are labeled with their industries. The British Isles are symbolized by three of the figures: the unlabeled central figure is that of a seaman with an anchor; *Coal* is a miner with his lantern and pick; and *Fish* is a man with a net and leaping fish. India is also symbolized by three figures: *Salt,* a woman carrying a bag; *Tobacco,* a woman with tobacco leaves; and *Sugar,* a man holding sugarcane stalks. Australia is symbolized by *Wool,* a shepherd with a crook and sheep. Canada is symbolized by *Wheat,* a reaper with his scythe and wheat stalks. Africa is symbolized by *Cotton,* a woman and cotton plants. Beneath the figures the artist has sculpted a stylized rising sun, symbolic of the onetime truism, "The sun never sets on the British Empire."

INDUSTRIES OF THE BRITISH EMPIRE

Carl Paul Jennewein
(1890–1978)

Installed
January 1933

Type
High-relief

Foundry
The Gorham Company, Providence, Rhode Island

Media
Cast bronze with gilding

Measurements
18 feet high, 11 feet wide

Location
Above 620 Fifth Avenue entrance

BRITISH COAT OF ARMS

Carl Paul Jennewein
(1890–1978)

Installed
January 1933

Type
Cartouche

Fabricator
Piccirilli Brothers,
New York City, New York

Media
Gilded and polychrome-
painted carved limestone

Location
Above 620 Fifth Avenue
entrance

Above *Industries of the British Empire* is a polychrome and gilded stone replica of the emblem of Great Britain. The cartouche is an amalgam of traditional British motifs. A banner below the shield carries the gilded motto of British royalty: *Dieu et mon droit* (French for "God and my [birth]right"). Inscribed on a belt surrounding the shield is the motto of the Order of the Garter: *Honi soit qui mal y pense* ("Evil to him who thinks evil"). The shield is divided into four sections. The first and fourth quarters symbolize England. They are red (gules) and each contains three gilded passant-gardant lions (*passant* means walking and *gardant* means looking out of the shield). The second quarter is symbolic of Scotland and is also red. Its motif is a gilded rampant lion (*rampant* means standing erect with one paw on the ground and the other three raised). The third quarter, symbolizing Ireland, is azure and displays the gilded harp of Tara. The entire emblem is surmounted by the royal crown, which is topped with a small gilded lion bearing a crown. On the left of the center shield is a large rampant gold lion bearing the crown of England. On the right is a rampant white unicorn with a crown around its neck and a chain on its withers. The unicorn is chained to indicate its power, and the belief that this mythical animal could only be subdued by a virgin. It is a symbol of Scotland. These figures are traditionally referred to as supporters as they flank and prop up the shield. They stand on a grassy hill where three other symbols of the British Isles can be found—the gilded Tudor rose of England, the thistle of Scotland, and the shamrock of Ireland. This insignia is currently used by the British reigning monarch and appears on all royal documents and letters, as well as on the façades of British embassies throughout the world.

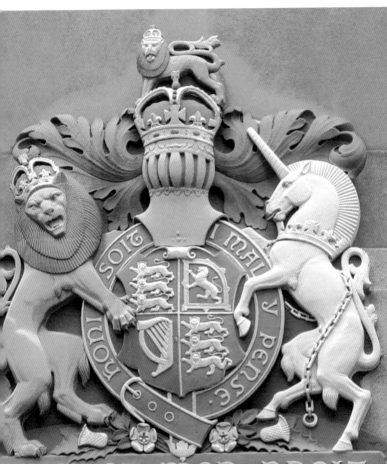

DIEU ET MON DROIT

MOTIFS FROM THE COATS OF ARMS OF THE BRITISH ISLES

Rene Paul Chambellan
(1893–1955)

Installed
1933

Type
Bas-reliefs

Medium
Limestone

Location
Fifth Avenue façade
sixth-floor spandrels

For this series of carvings Rene Chambellan borrowed motifs from the coats of arms of England, Scotland, Wales, and Ireland—the four countries that make up the British Isles. The carvings help publicize the building's primary tenant, which in the 1930s was the government of Great Britain. Part of four sets of interrelated architectural decorations on the low Rockefeller buildings along Fifth Avenue, these four bas-reliefs symbolize what is royally, historically, or mythologically significant in each country. First, from south to north, is *Wales*—a mighty rampant dragon with its wings spread wide above three heraldic plumes. The dragon is a symbol of power, wisdom, and one who has overcome its adversaries. It is traditionally red, its ears are batlike, and its tongue and tail are barbed. The plumes are traditionally silver (or white) and symbolize obedience—they were introduced by the Black Prince in the fourteenth century and are still found in the current Prince of Wales's coat of arms. When combined with the motto *Ich Dien* (German for "I serve"), they become his badge. *England* is a passant-gardant lion and a large Tudor rose. The lion symbolizes great courage and strength and

is traditionally gold, indicating royalty. The Tudor rose was adopted by King Henry VII, whose Welsh grandfather, Owen Tudor, married the widow of King Henry V and introduced the heraldic symbol as a royal emblem. *Scotland* is a powerful rampant unicorn and outsized thistle. The fabled unicorn is always white and is a symbol of virginity and has religious significance in connection with the Virgin Mary. It is frequently depicted chained as it was powerful and could only be subdued by a virgin. The thistle is the national flower of Scotland. It is the insignia of the Scots Guards and the Queen's Own Highlanders. *Ireland* is an elegant stag with surroyal antlers, a harp, and a shamrock. The stag indicates long life and regeneration of life owing to its ability to renew its antlers and is symbolic of wisdom and virility. According to legend, the one who killed the stag gained the right to rule. The harp symbolizes a mystical bridge between heaven and earth and is traditionally described as the Royal Harp of Tara. The shamrock, a trefoil, symbolizes the cross and the blessed Trinity. It is believed that its three leaves were used by Saint Patrick to demonstrate its religious significance.

ARMS OF ENGLAND

Lee Lawrie
(1877–1963)

Installed
1933

Type
Intaglio relief

Media
Polychrome and
gilding on limestone

Locations
Fiftieth Street entrance

The panel depicting three gilded passant-gardant lions reinforces the presence of the British monarchy in this building (*passant* means walking; *gardant* means looking out of the shield). This simple design is historically significant—the lions were first used to decorate the shield of Richard I, who, following the death of his father, became King of England at age thirty-two and ruled from 1189 to 1199. Richard I had spent most of his life in his mother's country, France. There he received the nickname *Coeur de Lion* ("lionhearted"), signifying his military prowess. Ever since the time of Richard I, these lions have been incorporated into the arms of the reigning sovereigns of England. A decorative row of red and gilded Tudor roses is carved below the lions. In the fifteenth century, the Tudor rose combined the houses of York and Lancaster and has remained an important symbol of royalty in Britain.

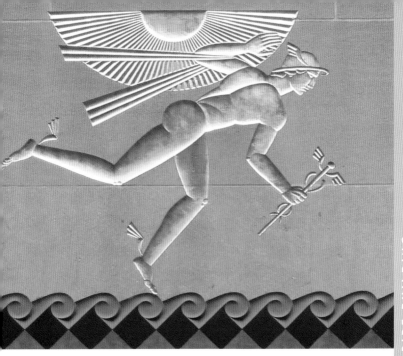

The Roman god Mercury has been used to symbolize Britain's worldwide strength in the 1930s. The gilded figure is depicted on a mission, rapidly flying over blue-green waves. He wears a small helmet signifying power and protection, and on his heels are small wings symbolizing swiftness. He carries a caduceus, the staff of ancient heralds. Above his head is a blazing sun carved in a stylized fan shape, illustrating the motto "The sun never sets on the British Empire." This gemlike panel stands for the wealth and vitality of the powerful British merchant fleets that built the empire and sailed the seas. The use of gilding reinforces the concept of prosperity. The carving is an intaglio, meaning carved or engraved into the stone without any areas being higher than the surrounding stone. This technique is usually found in small precious stones set in jewelry. The relief is a classic Art Deco architectural embellishment.

WINGED MERCURY

Lee Lawrie
(1877–1963)

Installed
1933

Type
Intaglio relief

Media
Polychrome and gilding on limestone

Location
Channel Gardens entrance

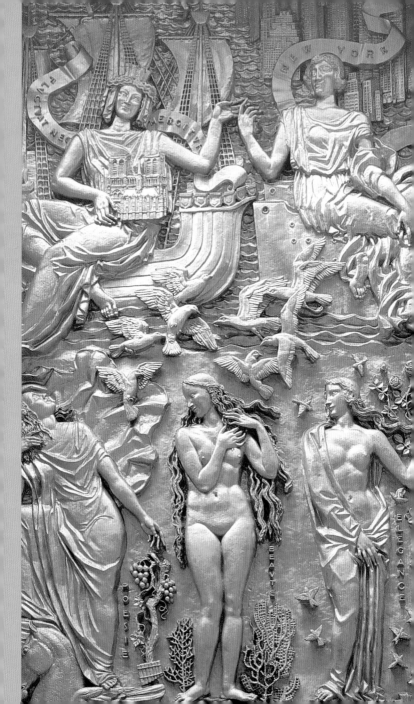

This gilded panel sparkles above the main entrance to La Maison Française. The panel is arranged in narrative form to be read from top to bottom. At the top are the two principal heroic-size female figures holding hands, symbolizing the alliance between the cities of Paris and New York. They are depicted floating on the prows of two ships, emblematic of sea commerce and trade between the nations. Above the left figure, who holds a model of Notre Dame Cathedral, is the motto of Paris, *Fluctuat nec Mergiture* (Latin for "it floats but never sinks"). Above the right figure is a banner simply inscribed *New York*. The skyscrapers of Rockefeller Center are seen behind her. Below the heroic females are the figures of three luxuriant Graces. Poetry, on the left, is draped and lost in thought as her robe flies up behind her. Elegance, on the right, is partially draped and demure. Beauty, in the center, is nude and narcissistic but not the least bit vulgar—she is exquisite. The graces signify the cultural exchange between the nations. The winged horse of mythology is found in the lower left corner and is symbolic of inspiration and imagination. It is here the artist chose to inscribe his name. A multitude of birds, branches, fruits, and corals are strewn across the plaque, contributing to the energy of the piece. This vigorous, undulating plaque is characteristic of Alfred Janniot's work. It cannot be considered an Art Deco work due to its classicism and vibrant, lace-like ornamentation. The gilding and overall decoration heighten the drama of the piece and make it unique to the city. The panel and the carved stone figure of *Gallic Freedom* (also known as the *Torch of Freedom*) above it are Janniot's only sculptures in America.

FRIENDSHIP BETWEEN AMERICA AND FRANCE

Alfred Janniot
(1889–1969)

Subject
Allegorical panel

Installed
January 1934

Type
Bas-relief

Foundry
Gorham Company,
Providence, Rhode Island

Medium
Gilded cast bronze

Measurements
18 feet high, 11 feet wide

Location
Above 610 Fifth Avenue
entrance

LA MAISON FRANÇAISE

GALLIC FREEDOM

Alfred Janniot
(1889–1969)

Installed
June 1934

Type
Cartouche

Carver
Piccirilli Studios

Media
Polychrome and gilded,
carved limestone

Measurements
10 feet high, 11 feet wide

Location
Above 610 Fifth Avenue
entrance

This massive figure commands attention from her perch above the entrance to La Maison Française. She is a majestic figure, symbolic of French freedom as she proclaims *Liberté, Egalité, Fraternité* (Liberty, Equality, Fraternity) to the world. She holds the gilded Torch of Freedom aloft in her left hand, evocative of the flame of revolution and its triumph. Her cream-colored toga and green cloak swirl around her immense white body, indicating the strife and effort that went into gaining the freedom that resulted in the French Republic. She wears the red cap of liberty (the Phrygian cap), traditionally symbolic of revolution, freedom, and the state. Gilded olive branches and laurel leaves are scattered about the figure, symbolic of victory and peace but also contributing to the vigor of the work. The figure is depicted as exultant and dignified because she has exposed herself to danger and triumphed. Danger is symbolized by her robe barely covering her left breast; triumph is obvious from her bearing. The sculpture references the energy and patriotism of the famed 1830s painting *Liberty Leading the People* by Eugène Delacroix. Both are forceful, partisan works. This carving is typical of Alfred Janniot's style in the use of strong details, a twisted pose, and deep undercuts—resulting in a dynamic sculpture. It was carved shortly after Janniot's gilded bronze bas-relief *Friendship Between America and France* was installed directly below. The stone was carved on site by the Piccirilli studio, following a model Janniot sent from France. The coloration of the figure was designed by Leon V. Solon.

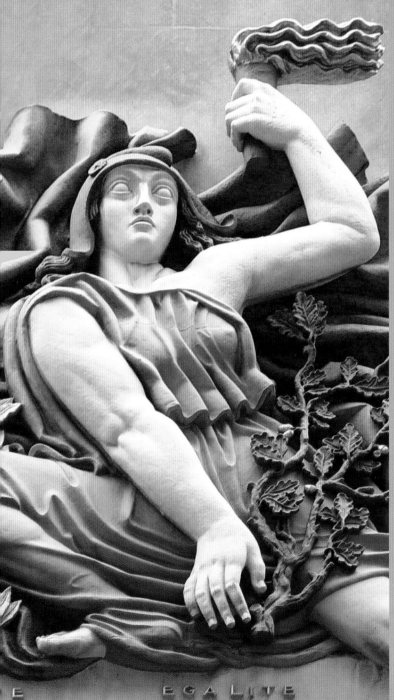

LA MAISON FRANÇAISE

EGALITE

PAGEANT OF FRENCH HISTORY

Rene Paul Chambellan
(1893–1955)

Installed
1934

Type
Bas-reliefs

Medium
Limestone

Location
Fifth Avenue façade
sixth floor spandrels

Rene Chambellan submitted symbols from four significant events in France's history to illustrate the theme A Pageant of French History. For the south spandrel—the *Roman Period*—he chose a sword with the letters *S.P.Q.R.* (*Senatus Populusque Romanus*), which translates "The Senate and the People of Rome." The next spandrel symbolizes the *New United France*, referring to the era when territories and duchies were united and France became a country. This message is conveyed by five spears bound together against a background of stylized drapery decorated with fleurs-de-lis, traditional symbols of France. The third spandrel illustrates *Absolute Monarchy Established Under*

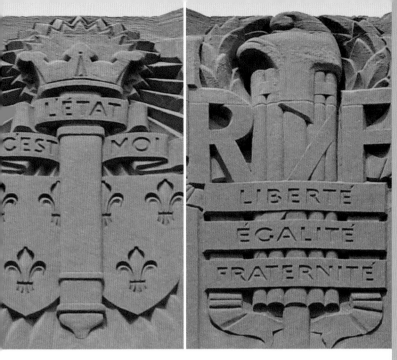

Louis XIV. This grand notion is conveyed by a crown atop a torch with deeply carved rays of sunlight emanating from behind. Below the torch are fleurs-de-lis and a banner inscribed with the words *L'État, C'est Moi* ("I am the state"). The final spandrel is a tribute to the *French Republic*. This concept is represented by the large letters *RF*, an abbreviation of Republique Française (the French Republic). The letters flank the motto of the French Revolution, *Liberté, Egalité, Fraternité* (Liberty, Equality, Fraternity), and three additional symbols of the Revolution—fasces (a bundle of rods) for unity, a Phyrgian cap for freedom and democracy, and a laurel crown for peace and victory.

The sterling silver model of a single-engine plane rests in a glass enclosed case, alarmed and humidity-controlled, in the building's lobby. It is an exact replica of the Hispano-powered Bréguet biplane that the famed French aviators, Dieudonné Costes and Maurice Bellonte, flew across the Atlantic Ocean in 1930. This flight originated in Le Bourget, France, and terminated at Curtiss Field, New York. The reverse of Lindbergh's famous flight in 1927 from New York to Paris, it took 37 hours and 18 minutes to fly. The model was a presented by the French Ambassador to the United States as a gift from the Republic of France to Rockefeller Center and was a public endorsement of the newly-built Maison Française. The model plane was handcrafted in France by the famed Cartier company. Their silversmiths worked side by side with engineers and technicians from the aircraft company Avion Bréguet, which built the original full-size plane, *Le Point d'Interrogation*. They supplied blueprints and specifications for creation of the model. Silversmiths in the Cartier workshops hand-formed each element from sheets of sterling silver. Every joint was meticulously fused, hand-chased, and finished. The propeller turns, the flaps move, the wheels rotate, and the cockpit opens. The red, white, and blue of the French flag are enameled on the wings and tail. Engravers commemorated the gift with a hand-engraved inscription on the fuselage. Finally, the entire plane was coated with a crystal-clear lacquer to protect its surface from tarnishing. The model is both a precious object and an exact replica. It is unique—only one was ever made.

THE QUESTION MARK (Le Point d'Interrogation)

Cartier and Co., Paris

Installed
October 1933

Type
Model

Media
Sterling silver and enamel

Measurements
48 inches from wingtip to wingtip, 28 inches long, 10½ inches high

Location
Channel Gardens entrance lobby

SEEDS OF GOOD CITIZENSHIP

Lee Lawrie
(1877–1963)

Installed
1937

Type
Intaglio relief

Media
Carved limestone, polychrome, gilding

Location
Channel Gardens entrance

This allegorical gilded female figure is sowing seeds, each in the form of a stylized fleur-de-lis, the symbolic flower of France. The panel is unadulterated Art Deco. The robust muscular figure wears the helmet of authority and the garb of a peasant woman. The dress underscores her connection with ordinary, real people—not gods and kings. Striding across a multicolored, gilded plowed field while effortlessly carrying a heavy sack and sowing seeds in a diagonal line to the tilled earth below, she appears indomitable. The simple coloration of green, terra-cotta red, and black with a gilded central motif, was designed by Leon V. Solon. He used gilding at both side entrances to La Maison Française, lending drama to otherwise simple architectural decorations.

Lee Lawrie repeated the fleur-de-lis motif found in *Seeds of Good Citizenship* to unify the French building's entrances and embellishments. The shapes he designed create simple, bold patterns. The stylized flowers are set above a geometric gilded and polychrome crenellated border suggestive of royal architecture. *Fleur-de-lis* translates as "flower of the lily," but in reality this was the iris, which commonly grows in the south of France. It was Louis VII of France who adopted the purple iris as his motif in the twelfth century. The floral badge of France for the next six hundred years, the fleur-de-lis was such a powerful symbol of the monarchy that the revolutionaries in 1789 set out to obliterate it completely, burning any banner or textile bearing it and chiseling off the hated royal symbol from buildings. It was so prevalent and loved, however, that to this day it remains a well-recognized icon signifying France. The fleur-de-lis is also a symbol of purity, and owing to its three petals is considered a representation of the Trinity.

FLEUR-DE-LIS

Lee Lawrie
(1877–1963)

Installed
1937

Type
Intaglio relief

Media
Carved limestone, polychrome, gilding

Location:
Channel Gardens entrance

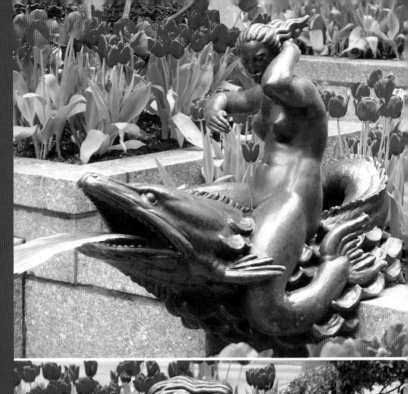
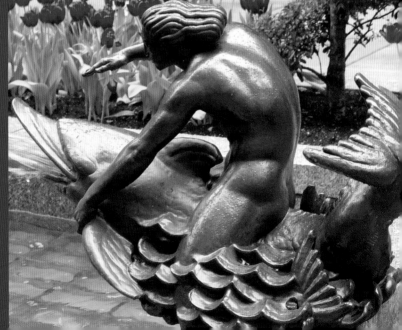

The excitement in the Channel Gardens lies primarily with six fountainhead sculptures gushing broad streams of water. The large female fountainheads are Nereids, mythological daughters of a benevolent sea god named Nereus and his wife Doris (the daughter of Oceanus, the unending stream of water encircling the earth). They are considered gentle mermaids who were protective of sailors and used their beautiful voices to amuse their father. The male figures are Tritons, also hybrids in that they have human heads and bodies with legs ending in fish tails. The first Triton lived in a golden palace at the bottom of the sea with his parents, the aquatic deities Poseidon and Amphitrite. The following generations, all called Tritons, became attendants of the sea gods. Inspired by these legends, Rene Chambellan created his Nereids and Tritons astride fanciful fish. From Fifth Avenue toward the lower rink, the first sculpture is *Leadership,* characterized by a muscular Triton with his head raised and blowing a large conch shell. He is a romantic clarion figure who guides and shapes the path the others will follow. *Will* is a Nereid determined to accomplish her mission through sheer determination. She has one hand raised and ready to strike if necessary; the other hand guides a large sea creature by pushing on its gill. *Thought* is a Nereid deeply concentrating and developing the solutions to the tasks ahead. Her head is bowed and touched by one hand; the other hand provides balance as she rides sidesaddle. *Imagination* is symbolized by a Nereid with one hand slicing the air as if cutting a new and unique path. *Energy* is a Triton who leans aggressively forward and is a portrait of vigor and power. *Alertness* is symbolized by a strong-minded and decisive Triton. He is vigilant and aware of any pitfalls that might befall mankind. His arms are spread wide and his face turned as if something has caught his attention. His mount's head is raised and its eyes are wide open as if it also is on guard.

FOUNTAINHEAD FIGURES

Rene Paul Chambellan
(1893–1955)

Installed
circa 1935

Type
Sculptures

Foundry
Roman Bronze Works,
Long Island City,
New York

Medium
Cast bronze

Measurements
Each figure approximately 3 feet high

Location
East ends of the six pools

DRAIN COVERS

Rene Paul Chambellan
(1893–1955)

Installed
circa 1935

Type
Sculptures

Foundry
Roman Bronze Works,
Long Island City,
New York

Medium
Cast bronze

Measurements
Range from 10 inches
to 16 inches wide

Location
West ends of the six pools

At John D. Rockefeller Jr.'s suggestion, Rene Chambellan was commissioned to make whimsical drain covers for each pool in the Channel Gardens. The suggestion for decorative castings to hide the drains was brought up at a meeting of the architects. These meetings were concerned with every feature, no matter how small, that went into the building of the Center. In order to help the artist conceptualize Mr. Rockefeller's idea of artistic drain covers, Rene Chambellan was invited to visit Kykuit, the Rockefellers' fabled estate in Tarrytown. At Kykuit, there was an underground grotto containing similar capricious carvings. Inspired, Chambellan returned to his studio and created a variety of small sea creatures, crabs, starfish, turtles, octopuses, and seashells. Chambellan meticulously reproduced every detail found on the small aquatic creatures. They appear to have emerged spontaneously as if they had just arisen from the churning waters of the sea. Some of the drain covers are simple figures; others are piled on top of rocks and shells. The crab has large claws, a broad shell, and bulging eyes. It rests on an easily recognizable fluted scallop shell. The starfish has attached itself to a conch shell and appears ready to pry it open. The turtle's carapace shields are well defined, its claws spread out and detailed, and its reptilian head lifted high and looking toward the viewer. In the pool nearest the skating rink there are two drain covers: one is a turtle on a rock and the other is an octopus. All the castings have brown patinas with golden highlights, echoing the fountainheads' coloration. The creatures not only disguise the drains in a novel way but are also indicative of the attention to detail that makes Rockefeller Center fascinating to the visitor and unique in New York.

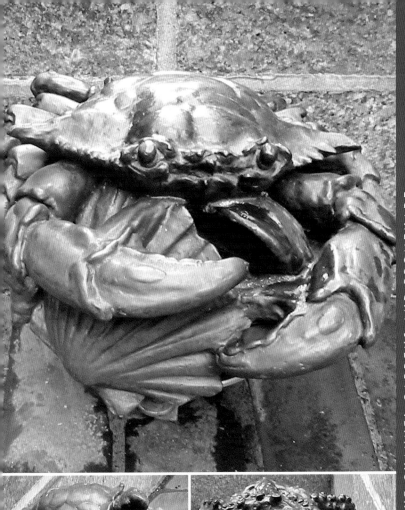

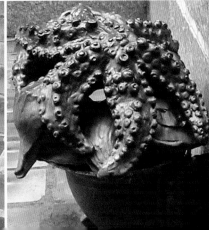

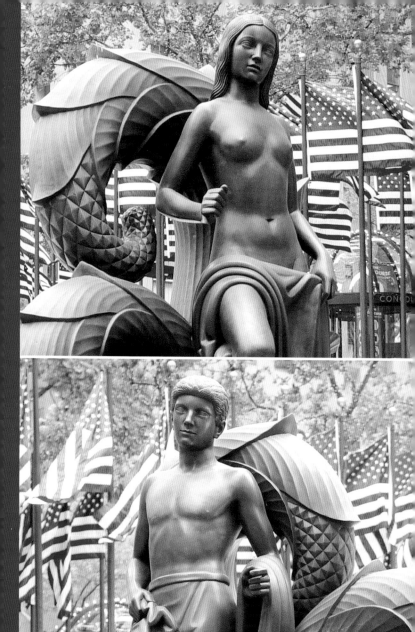

In 1933, Paul Manship created these heroic-sized figures to flank the golden Titan *Prometheus*. At that time they were gilded and stood on the granite shelves on either side of the great Titan's fountain. They were vital elements in the depiction of the myth of Prometheus giving mankind the gift of fire and formed what is artistically called a sculptural group. After installation, Manship was not satisfied with the grouping and had the figures placed in a number of other sites, but always in the environs of *Prometheus*. None of the installations seemed to appeal to him at the time, and the figures were removed and stored on the roof garden of the British Empire Building. They remained there for fifty years until 1983, when they were rescued from oblivion, restored, given a traditional brown patina, and placed in the skating rink on new pedestals. In 2001, during a restoration of the rink, they were moved to pedestals in a new prominent location near the staircase where they announce *Prometheus*. The simplified, well-crafted figures are typical of Manship's formal style. They are formed with smooth planes, gracefully carved masses, and a discreet use of rhythmic patterns. Neither figure is completely nude or provocative, as none of Manship's figures ever suggest sexual energy. They are depicted frontally, standing next to exaggerated reptilian branches of vegetation symbolic of the Garden of Eden. Despite the fact that mankind is about to be changed forever, their postures suggest boredom and weariness. Each figure slightly tilts its head, raises one knee, and holds its robe in one hand. If any fault is to be found with the two sculptures, it is that there is no excitement here; they are too stilted for the theme and too apathetic for their roles. Perhaps that is why Manship had them separated from *Prometheus*.

MANKIND FIGURES (MAIDEN and YOUTH)

Paul Manship
(1885–1966)

Installed
1934

Type
Sculptures

Foundry
Roman Bronze Works,
Long Island City,
New York

Medium
Cast bronze

Measurements
Each figure 8 feet high

Location
Flanking staircase
to Lower Plaza

CHRISTMAS ANGELS

Valerie Clarebout
(dates unknown)

Installed
1954

Type
Sculptures

Fabricator
Artist

Media
Aluminum wire, paint,
brass wire, lights

Measurements
Each figure 8 feet high

Location
Installed for
Christmas holidays
in Channel Gardens

In winter the Channel Gardens fountains are turned off and the Center is decorated for the Christmas holidays. For many years the decorations varied—sleighs, snowmen, carolers, and jack-in-the-boxes decorated the gardens. In 1954, twelve wire-sculpture angels created by Valerie Clarebout were introduced. A few years later they became permanent fixtures at Christmastime. Standing amid small pines, sparkling wire snowflakes, and Christmas boughs, they herald the holiday season at Rockefeller Center. The joyful figures hold six-foot-long brass trumpets angled toward the famed Christmas tree. Clarebout designed both the figures and the luminous snowflakes to sparkle with light and energy from thousands of tiny glittering lights. She created the shapes by bundling hundreds of individual lengths of different-gauge wires together and fastening them to an aluminum armature. Within these forms she delicately wove fine-gauge brass wires to create the figures' halo, sleeves, collar, and sash. These details appear to be embroidered. Finally, the figures were spray-painted white and strung with small twinkling white lights. The angels are so translucent and ethereal they appear as if they've just materialized among the snowflakes to herald the Yuletide.

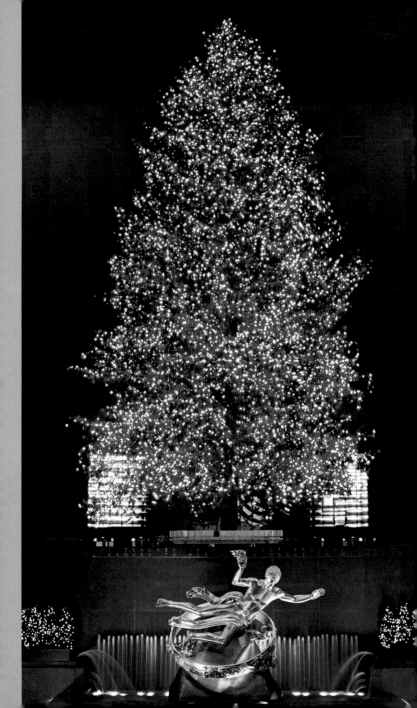

Prometheus is the best-known sculpture in Rockefeller Center. It was created by the famed American sculptor Paul Manship. The gleaming gilded figure can be seen from Fifth Avenue through the Channel Gardens and is the main attraction of the Lower Plaza, where it sits in the center of a large granite fountain. Playful water jets splash around the figure and up onto the wall behind him. Carved in this red granite wall is a quote from the sixth-century B.C. Greek dramatist Aeschylus, "Prometheus, Teacher in Every Art, Brought the Fire That Hath Proved to Mortals a Means to Mighty Ends." The quote encapsulates the sculpture's theme. Manship was fascinated by mythological subjects and events and had studied classical art. In this sculpture he unites these interests in his own original manner, shaping the myth of Prometheus into a unique, decorative form. Manship depicts Prometheus conveying stolen fire from the Chariot of the Sun to give it to mankind to improve their miserable world. Manship catches this critical moment and the essence of the thievery. Prometheus is shown plummeting to earth with his right arm raised holding his prize aloft, his left hand reaching out to balance his descent. As he descends, his robes fly outward, his mouth opens slightly, and his eyes are fixed on his target. Prometheus was a rebel and knew this act would anger the gods. Zeus, king of the gods, responded violently. He had reserved the power of fire for the gods and did not it want it to strengthen or benefit anyone else. He had Prometheus captured and chained to Mount Caucasus, and set about punishing him for eternity. In a never-ending cycle, Prometheus suffered the consequences of his crime—every day his liver was eaten by a giant vulture and every night his liver regrew. Finally, he was rescued by Hercules, a brother insurgent. In Manship's hands, the myth is explicit and the symbolism obvious—earth is represented by the huge mountain, the seas by the pool, and the heavens by the zodiac ring. *Prometheus* remains the focal point of the Center all year round. In the spring and summer it is the centerpiece of the outdoor restaurant. In the winter it is bedecked in pine boughs and twinkling lights, adding to the holiday atmosphere. It is said that *Prometheus* is the most photographed monumental sculpture in New York City, which supports the idea that Rockefeller Center is the very heart of the city.

PROMETHEUS
(see also front cover)

Paul Manship
(1885–1966)

Installed
January 1934

Type
Heroic-sized sculpture

Foundry
Roman Bronze Works,
Long Island City,
New York

Medium
Gilded cast bronze

Measurements
18 feet high

Weight
8 tons

Location
Fountain west wall

ITALIA

In 1965, a group of prominent Italian businessmen presented Rockefeller Center with this bronze bas-relief as a symbol of Italy and Italian-Americans. During the Second World War a bas-relief with an undesirable fascist theme had been removed from this prominent location. Over a twenty-year period there had been attempts to replace it with a sculpture that would represent both postwar Italy and the Italian Americans. Finally, the prominent Italian sculptor Giacomo Manzu agreed to accept the commission for this plaque as well as a companion piece that was to be part of the total concept. He created this large, simple bas-relief bearing the word ITALIA in high bold letters at the top and an ornate agricultural motif in the center. The bas-relief is uniquely linked to Manzu's native land—it can have no other possible theme or universal relevance. It is a grouping of entwined cuttings of grapevines, leaves, and stalks of wheat. The broad, level, empty surface around the central motif is effective—the viewer is compelled to focus attention back and forth between the central motif and the word ITALIA, uniting the elements and the theme. The patina is a rich golden brown. The motif is classically rendered, and the letters ITALIA are in a simple type style. It is not an Art Deco statement, but it does not contrast or challenge the architecture. It's a restrained architectural sculpture that functions well in its setting. Manzu created a smaller companion bas-relief titled *The Immigrant,* which until 2001 was installed directly below this work and was part of the unit. It can now be found near the Fiftieth Street entrance to this building. Giacomo Manzu is renowned for his bronze doors at St. Peter's Cathedral (Basilica di San Pietro) in the Vatican, which he created the year before he produced these works for Rockefeller Center.

ITALIA

Giacomo Manzu
(1908–1994)

Installed
May 1965

Type
High-relief

Foundry
Modern Artistic Foundry, Milan, Italy

Medium
Cast bronze

Measurements
15 feet 7 inches high, 10 feet 5 inches wide

Location
Above 626 Fifth Avenue entrance

PALAZZO D'ITALIA

THE IMMIGRANT

Giacomo Manzu
(1908–1994)

Installed
May 1965

Type
Bas-relief

Foundry
Modern Artistic Foundry,
Milan, Italy

Medium
Cast bronze

Measurements
6 feet 6 inches high,
3 feet wide

Location
Near West Fiftieth Street
entrance.

This bas-relief is the companion work to the large panel titled *Italia*, installed over the Fifth Avenue entrance. Originally *The Immigrant* was installed below the large panel, making a unified statement. It was moved for the sake of commerce during a renovation of the storefront. It is a poignant work depicting a weary barefoot mother and her naked child, representing the fundamental nature of poverty. Resting against a rock, the pair have tied their worldly possessions in a cloth bundle that hangs from a stick—the mother and her child are alone in the world. She is the Italian woman who, after the war and the loss of so many Italian men and homes, despaired and left Italy to seek new beginnings in America. Manzu is quoted as saying, "It is the immigrant's search for two principal things—drinking and eating." Manzu sketched leaves and branches in the background, in a technique called *sgraffito*, and carved the figures and the bundle in low relief to make the panel appear as if it is still in process, as the immigrant's search for new beginnings is still a developing story. It is very different from its companion panel *Italia*, which is stark, formal, and relates to the Italian nation. In *The Immigrant*, Manzu captures universal human despair combined with a modicum of hope.

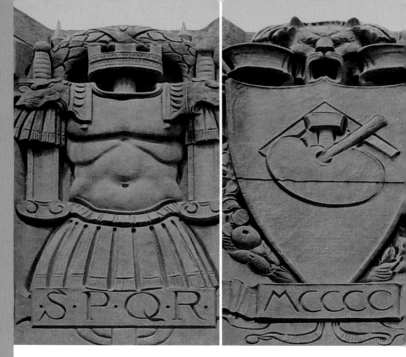

FOUR PERIODS
IN ITALIAN HISTORY

Leo Lentelli
(1879–1961)

Installed
1935

Type
Bas-reliefs

Medium
Limestone

Location
Fifth Avenue façade
sixth-floor spandrels

Embellishing the spandrels of the Palazzo d'Italia are stone carvings that represent four eras in Italy's history. The carvings begin with the Romans, then continue to the Italian Renaissance, to Italian independence, and culminate with the fascist Italian government led by Benito Mussolini. *The Roman Period* is represented by the letters *S.P.Q.R* ("The Senate and People of Rome"). These letters are surmounted by a Roman warrior's breastplate and kilt, flanked by columns terminating in sword hilts. At the top rests a crown and stylized wreath symbolic of power. *The Italian Renaissance* is recognizable by the date carved in the Roman numerals MCCCC (1400). That is the date universally accepted as the beginning of the Italian Renaissance. This era is symbolized by a shield decorated with a palette, brushes, and a square denoting the arts and architecture. At this time in Florence, the power and wealth of the Medici family made it possible for intellectual and artistic enterprise to flourish, and endowed the Renaissance. *Italian Independence of 1870* was the climax of a series of political and military events. A united Italy was established in 1861 with Victor

Emmanuel as its king. However, the kingdom was missing Rome, a papal possession and under France's protection. In October 1870, when Napoleon III withdrew his troops, Italian troops moved in and unification was complete. Independence is represented by heavily draped flags flanking a shining star. Below the flags is the motto *Morte o Libertà* (Italian for "Death or Liberty"). *The Fascist Regime* began in Italy in 1922 when Benito Mussolini was appointed prime minister. He soon assumed the title *Il Duce* (the Chief) and instituted policies of belligerent nationalism, racism, and aggression. In this carving, his beliefs are illustrated by bold fasces surmounted by an eagle with its wings outstretched. Mussolini associated the new Italy with Roman grandeur. Both classic Roman totems, the eagle symbolizes power and the fasces unity. Originally the Roman letters AXII (Anno XII) were carved across the center of the fasces, signifying 1935, the twelfth year of fascism and the year this carving was installed. It didn't take long before Italian Americans and the Rockefellers found this date an unacceptable reference and had it removed from the sculpture.

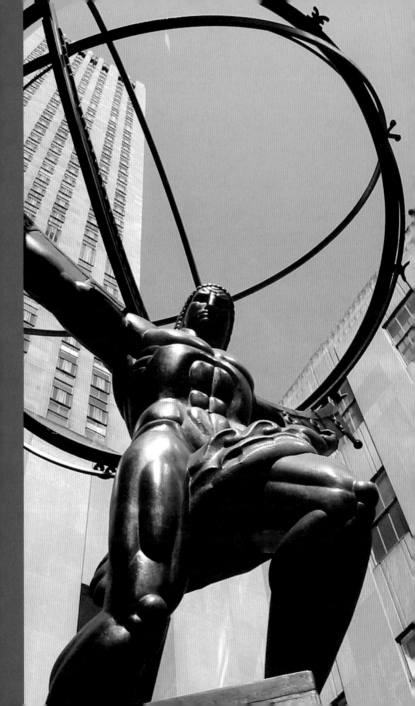

This statue of the colossal Titan Atlas was a collaborative effort by two extremely talented artists. Lee Lawrie conceived the idea and designed the figure, and Rene Chambellan modeled the heroic-sized statue from his sketch. Standing in a prominent place, it is one of the main attractions at Rockefeller Center and sets the stage for the themes and Art Deco style found in the Center. The story of Atlas is from Greek mythology. A brother of Prometheus, Atlas was a Titan, one of the race of half-god half-man giants who warred against Zeus and the Olympic gods. Eventually, the Titans were defeated and Atlas was condemned to carry the world on his shoulders for his role in leading them against the gods. In this sculpture Lawrie represents the world with an armillary sphere bearing the twelve signs of the zodiac; its axis pointing to the North Star. Lawrie designed the muscular Titan standing on a slim, simple pedestal, with knees bent and one leg overhanging his perch. This precarious position accentuates the great effort Atlas is making as he raises his burden. Every muscle of his huge body is modeled—every form is defined, full, gleaming, and smooth. His face is deeply furrowed as he focuses on his task; he is the quintessence of power and potency. The warm brown patina draws attention to the figure and contrasts it with the pale limestone façade of the building. The architects designed the pedestal so that its corner faces Fifth Avenue, not one of its sides. This was in order to provide an impression of easy flow and ample space in the forecourt. The figure is recognizable worldwide as one of the Art Deco icons of the Center and has been used on United States postage stamps.

ATLAS

Lee Lawrie
(1877–1963)
and
Rene Paul Chambellan
(1893–1955)

Installed
January 1937

Type
Heroic-sized sculpture

Foundry
Roman Bronze Works,
Long Island City,
New York

Medium
Cast bronze

Measurements
15 feet high on
9-foot granite pedestal

Weight
Seven tons

Location
630 Fifth Avenue main
entrance forecourt

LIGHT AND MOVEMENT

Michio Ihara
(1928–)

Installed
July 1978

Type
Sculpture

Fabricator
Artist in studio
and on-site

Media
Stainless-steel wire,
copper leaf, gilded sheet
metal and light

Measurements
Each sculpture
35 feet high, 7 feet wide,
2 feet deep

Location
Main-lobby north and
south walls.

In 1935, the architects planned the International Building lobby as one of the main entrances to the Center from Fifth Avenue since it connects by underground arcades to every other building in the Center. They envisaged the lobby as a grand hall—its towering space four stories high, its walls sheathed in green Tinos marble, and its ceiling covered in burnished copper leaf. In the center of the lobby is a broad bank of chromium-steel escalators that lends an aerodynamic feeling to the space. Set into the north and south walls are ten elements of a multipiece work by Michio Ihara. The sculpture frequently goes unnoticed as art because many people regard it as a source of light for the lobby. The parts do serve the purpose of lighting the area, but that is incidental to the artistic statement. The sculpture was commissioned in 1978 by Nelson Rockefeller, who was a great patron of modern art, admired Ihara's work, and wished to update and enhance the lobby area. Ihara's sculpture replaced illuminated advertisements that by 1978 were considered unattractive, commercial, and old-fashioned. Although each element is unique unto itself, the ten units together are considered a single work of art. It adds softness and elegance to the area and creates a haze of light that lessens the cold steel and stone of the modern lobby and entrance. The sculptures embody the essentials of reflected light and movement, two qualities typical of Ihara's work. There are nearly sixteen hundred rectangular metal leaves with gold patinas individually attached to vertical stainless-steel cables. In each of the ten elements, the leaves vary in placement. Some are grouped closely; others spread apart—no two are alike. Small fans and heat from the lights below create drafts which cause slight movement in the leaves, creating flickering shadows and mysterious light patterns. The sculpture is set against a flat background of copper leaf. The lighting is produced by quartz lights that were chosen for their durability, color, and intensity. Ihara used modern lights and man-made materials as his palette to produce a synergism between art and technology that expresses a glowing radiant calm silently embracing the passerby.

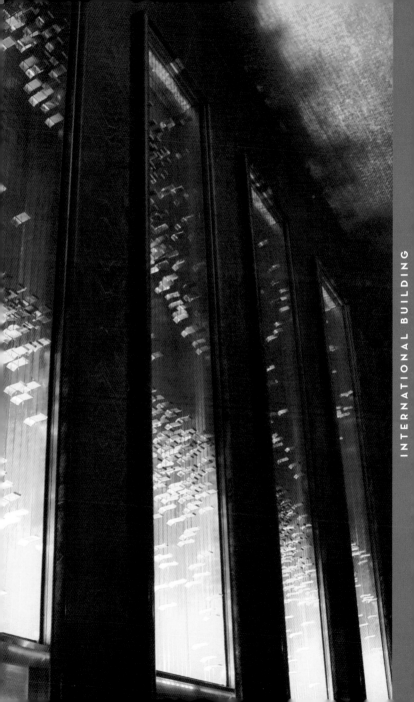

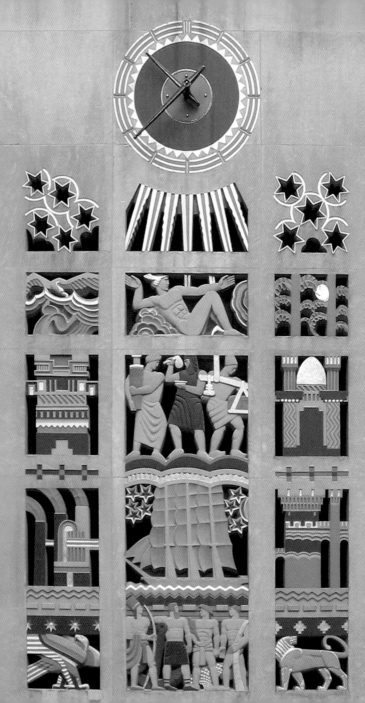

This massive carved limestone screen was created to symbolize the purpose of the International Building and chronicle mankind's progress. Lee Lawrie achieved this goal by dividing the screen into fifteen small rectangular spaces containing carved images that he termed "hieroglyphs." The message starts at the bottom center with four stereotypical figures depicting the races of mankind: red, white, yellow, and black. Directly above them is a sailing ship symbolizing international trade. The panel above the ship contains three male figures representing art, science, and industry—universal skills that helped develop the civilized world. Above these figures is the god Mercury, the mythical messenger, symbolizing worldwide communication and trade. At the top, the earth is represented by a clock and its rays. It is flanked by the two hemispheres, which are symbolized by the Big Dipper and the Southern Cross. The regions where the races dwell are represented by a seagull and a whale's fluke for the North, palm trees for the South, a mosque for the East, and an Aztec temple for the West. A Norman tower signifies agrarianism or pre-industry; three smokestacks symbolize the new industrial age. A lion is emblematic of the kingdoms of the world; the eagle represents the republics. Lee Lawrie's carefully organized design and his use of open spaces creates an innovative architectural embellishment. Rene Chambellan worked with Lawrie to create the model, and Leon V. Solon designed the coloration, thereby creating a colorful screen and powerful Art Deco embellishment to the building.

THE STORY OF MANKIND

Lee Lawrie
(1877–1963)

Installed
September 1937

Type
Sculptural grille

Media
Carved limestone, polychrome, and gilding

Location
29 West Fiftieth Street entrance

SAINT FRANCIS
OF ASSISI WITH BIRDS

Lee Lawrie
(1877–1963)

Installed
September 1937

Type
Intaglio carving

Media
Limestone, polychrome,
and gilding

Location
Above 9 West Fiftieth
Street entrance

The easily recognizable figure of Saint Francis is a universal symbol of love of self and neighbor. Born in 1181 in Umbria, Italy, the Italian saint was the son of a wealthy cloth merchant and did not start life as a religious man. He had a misspent youth that caused his family grief and led him to spend time in jail. During one imprisonment, he had a conversion experience in which he received a message from Christ that altered his life. He renounced the material world, devoted himself to the Gospels, and served mankind as a simple priest practicing extreme poverty. He tended the sick, preached in the street, lived with animals, cared for lepers, cleaned churches, and slowly began to attract followers. In 1212, with papal blessing, he founded the Order of Friars Minor (Franciscans). They were the first mendicant friars and they followed the Gospels literally. The Franciscans rejected materialism and, in those days, did not own or build monasteries. They lived in the streets, in poverty, as brothers devoted to the church and dependent on the world around them. Saint Francis was well known for his love of animals. In this carving, he wears the austere brown friar's robe fastened by a rope cincture with three knots at the end. This simple garb is symbolic of the order he founded. His feet are bare. Behind his head is the halo of sainthood in which gilded doves fly—the sign of the Holy Spirit. Sharing the meager meal in his begging bowl with a bird, he gazes upward, seemingly thankful. Saint Francis was the first person to receive the stigmata. Two years after his death he was canonized by Pope Gregory IX. The formality of Lawrie's composition, the simplicity of the design, the use of gilding, and the shallow depth of the carving give this architectural embellishment the appearance of an illuminated manuscript.

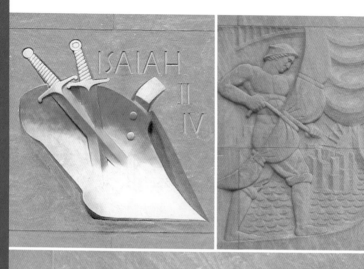

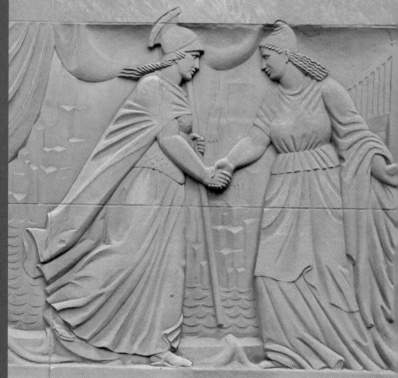

Over the entrance is a gilded intaglio carving of a plow-share with crossed swords rising from its surface. Next to it, carved in simple block letters, is Isaiah II:IV (refer-encing "And he shall judge among the nations, and shall rebuke many people: and they shall beat their swords into plowshares, and their spears into pruning hooks; na-tion shall not lift up sword against nation, neither shall they learn war any more"). This panel is one unit of the three-part work Lee Lawrie created as an appeal for world peace. The other elements are *Columbia Greet-ing a Woman* and *Boatman Unfurling a Sail*. This simple gilded carving is beautifully rendered and a serene com-position with a clear message. The use of gold leaf against the gray limestone accentuates the meaning of the message and makes the sculpture more authorita-tive. In this beautifully rendered Art Deco design, Lee Lawrie makes a potent spiritual statement. The carving is intaglio style—level with the surrounding surface as a gemstone might be carved.

SWORDS INTO PLOWSHARES

Lee Lawrie
(1877–1963)

Installed
September 1937

Type
Intaglio carving
and bas-reliefs

Media
Carved limestone
and gilding

Location
19 West Fiftieth Street
entrance

On the south façade of the building, at ground level, is a carved limestone panel of an allegorical scene of the New World. The main figure is Columbia, the feminine symbol of America. She is shown grasping the hand of an immigrant, welcoming her to America. The immigrant has just disembarked from a ship. In the background, small, neat waves indicate the ocean. Columbia wears a soft felt liberty cap, which derives from caps worn by newly lib-erated slaves of ancient Rome. The woman arriving is wearing a helmet, giving her the appearance of someone who has fought and won freedom. Columbia gestures with her hand, indicating the way to the New World and independence. The skyscrapers of Rockefeller Center rise in the background, reinforcing the concept of the New World. The corner pier is draped with sails, which carry the eye over to the adjacent panel *Boatman Un-furling a Sail*. The boatman is a muscular youth standing on the ship and focused on his work. The ship is the means to freedom; its sails and waves provide texture and rhythm to the panel.

COLUMBIA GREETING A WOMAN and BOATMAN UNFURLING A SAIL

Lee Lawrie
(1877–1963)

Installed
September 1937

Type
Intaglio carving
and bas-reliefs

Medium
Carved limestone

Location
19 West Fiftieth Street
entrance

FOURTEEN HERALDIC SHIELDS

Lee Lawrie
(1877–1963)

Installed
1937

Type
friezes intaglio carved

Media
Limestone,
polychrome, gilding

Location
20 West Fifty-first Street

The original embellishment for this entrance was a representation of various nations' historical symbols, primarily royal shields. Notable heraldic shields were researched and Lawrie developed a preliminary sketch, but soon the idea was discarded. The concept went through several refinements before Lawrie settled on a frieze of fourteen imaginary shields that would simply be decorative. This simple band of fantasy shields, with its emphasis on color and pattern, stands out against the plain façade and helps locate and decorate the entrance. The presence of any shield, even a fantasy one, suggests a global view in keeping with the internationalism of the building. Once again, Leon V. Solon and Lee Lawrie collaborated on the coloration.

For the astute viewer, this enigmatic panel by Lee Lawrie suggests the activities and wealth to be found within this building. The polychrome-painted stone carving depicts a messenger soaring from the clouds, emptying an overflowing horn onto the earth. The meaning of the panel is somewhat difficult to understand. Lee Lawrie wrote that it symbolizes "the plenitude that would result from well-organized international trade." The theme is compatible with the activities of the building, even if the art does not clearly reflect the subject matter. From the point of view of purely embellishing the building, the art is certainly effective. The figure emerges from a geometric, V-shaped cloud speeding toward a row of waves. The bold sweep of the female angling downward, her golden hair flowing, and the contents of the cornucopia dramatically spilling, skillfully conveys a feeling of motion and energy. The simple coloration, highlighted with gilding, was designed by Leon V. Solon.

CORNUCOPIA OF PLENTY

Lee Lawrie
(1877–1963)

Installed
1937

Type
Friezes intaglio-carved

Media
Limestone, polychrome, gilding

Location
10 West Fifty-first Street

TO COMMEMORATE
THE WORKMEN
OF THE CENTER

Gaston Lachaise
(1882–1935)

Installed
May 1935

Type
Bas-relief

Carver
Gaston Lachaise

Medium
Limestone

Measurements
Each panel 7 feet high,
12 feet wide

Location
Above 45 Rockefeller
Plaza entrance

These two sculptures are enduring tributes paid by capitalism to labor. The sculptures are most unusual because the subject matter is the glorification and recognition of the workmen who contributed to the actual hands-on building of Rockefeller Center. The sculptures were created by the French-born artist Gaston Lachaise, who, upon immigrating to America, abandoned European academic concepts and charted his own artistic course. His typical subject matter was the celebration of the human body and he certainly fulfilled that theme with these sculptures. The south panel depicts two workmen clearing the site. One holds a crowbar and the other carries an acetylene torch. Behind them is a relic of the past—an old fluted column representing the destruction of the site. On the north panel, the workers are riding a steel beam that is being hoisted upward, where it will be riveted into place, creating a modern building for the Center. The workers in both sculptures are depicted as muscular, semidressed, heroic male figures that idealize both manual labor and supreme physical beings. Lachaise is known for his ample, smooth, strong shapes and curvilinear forms. His knowledge of human anatomy and musculature dominates these panels; these figures are the essence of manliness. It is apparent in this commission that Lachaise was given artistic freedom, because the forms are clearly his personal expression of the assignment, without a committee judging and altering his vision as was the case with his other work for the Center, *Gifts of Earth to Mankind*. The commission of these panels commemorating the workmen of the Center by the Rockefellers permanently honors their respect for labor.

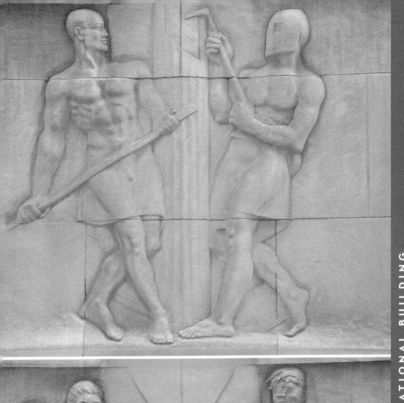
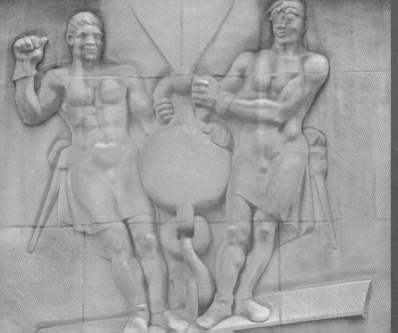

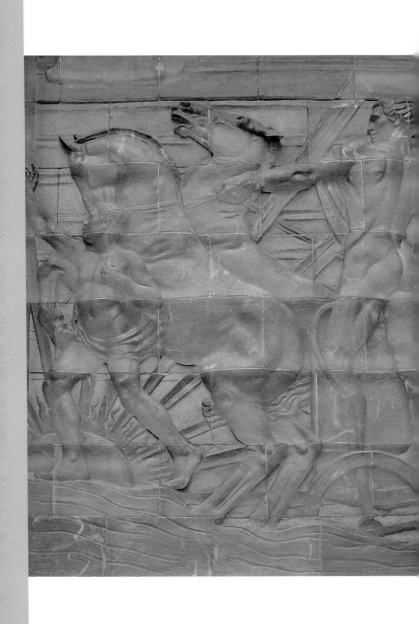

In 1936, at the time *Youth Leading Industry* was cast, political forces were gathering in Italy. A sense of a bold, self-confident and modern future was emerging. Unfortunately, it was under the leadership of the fascist dictator, Benito Mussolini. The Italian American artist Attilio Piccirilli captured the energy of this movement in his bas-relief and glorified it—a tribute he may have regretted, since his nephew served and died in the Second World War as an American soldier. The bas-relief was cast in forty-five Pyrex glass blocks—a groundbreaking use of Pyrex as an artistic material. Each block was hand-cast and unique. After the casting in glass, the models and molds were destroyed. No two are alike and no others exist in the world. The small bubblelike imperfections in the glass were deliberate and consciously included to simulate fluidity. Corning Glass Works dubbed it "poetic glass." The subject matter is pure neo-Roman and is a typical fascist theme of the 1930s: A youth shall lead the way. The bas-relief embodies the strength and energy of those formative years. It looks toward the future and better times for Italy with the young fascist party's leadership in commerce, industry, and world affairs. The vigorous, almost nude figure dashing ahead of the rearing horses represents its empowerment and destiny. The chariot and powerful horses symbolize the strength of the new industries and transportation. They are controlled by a confident charioteer (their leader) who skillfully guides them into the future. Piccirilli created the scene using all the artistic devices of flamboyant realism—classical symbolism, bulging muscles, pulsating movement, and theatrical poses. Lit from behind, it remains one of the highlights of an evening stroll down Fifth Avenue.

YOUTH LEADING INDUSTRY

Attilio Piccirilli
(1868–1945)

Installed
May 1936

Type
Bas-relief

Foundry
Corning Glass Works,
Corning, New York

Medium
Cast Pyrex glass

Measurements
16 feet high, 10 feet wide

Location
Above 636 Fifth Avenue
entrance

COMMERCE AND INDUSTRY WITH A CADUCEUS

Attilio Piccirilli
(1868–1945)

Installed
May 1936

Type
Cartouche

Media
Polychrome-painted limestone

Location
Above 636 Fifth Avenue main entrance

Above the glass bas-relief *Youth Leading Industry* is a large polychrome-painted limestone cartouche of two monumental-sized figures symbolizing the basic trades of a nation. The male figure represents commerce and the female figure symbolizes industry. A large caduceus, significantly placed between the figures, is a symbol of Mercury, the god of trade. Attilio Piccirilli sculpted idealized, superhuman figures, which reinforce the concepts of divinity and patronage, and applied them to the worlds of industry and commerce. They are muscular and toned and are depicted in utterly relaxed and confident poses. The kneeling, mostly nude figures face forward, revealing their majestic forms and confronting the world. The male figure has one hand resting on the handle of a sledgehammer, and his chiseled face stares confidently ahead. The female figure holds the edge of a robe that is draped over her shoulder, revealing her body. Her other hand rests on a cog. She, too, defies the world with her steadfast gaze and straightforward, calm demeanor. The artist has placed their pale bodies against the protective red and gold wings and caduceus of Mercury. The placement of the smooth figures against the boldly colored and textured background ensured that they would be clearly defined, independent of one another and the focus of the cartouche. These impressive figures, under the aegis of Mercury, embody and idealize industry and commerce, elevating them above any notion that business is crass. The stone cartouche is characteristic of Piccirilli's work, with its great energy, superb design, and classic forms.

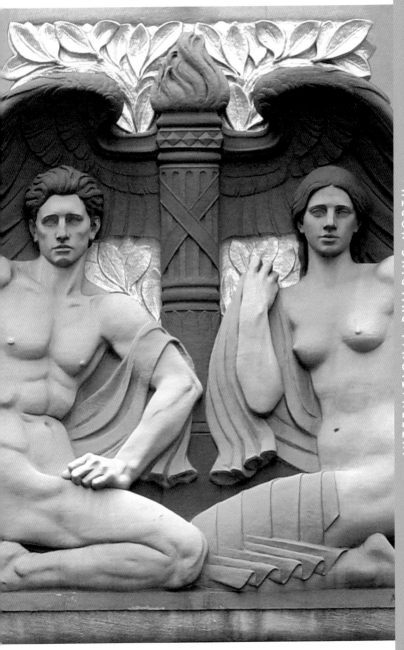

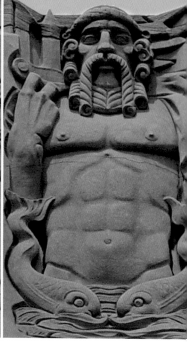

FOUR CONTINENTS

Leo Lentelli
(1879–1961)

Installed
May 1935

Type
Bas-reliefs

Medium
Limestone

Location
636 Fifth Avenue
sixth floor façade

The Italian-American artist Leo Lentelli was chosen to create themes that would reflect the range of the international businesses within the building. His allegorical carvings of four continents are, from south to north: *Asia, Europe, Africa,* and *The Americas. Asia* is clearly recognizable from the serene, meditating Buddha in the lotus position, symbolizing the piety and scope of the dominant faith of that continent. Above the Buddha's head looms an elephant decorated with jewels and tassels, representing the strength and wealth of Asia. *Europe* is represented by the mythical god Neptune rising from out of the ocean. He is a bold, stylized figure. Along the bottom edge are two large dolphins frolicking in the ocean. Above his raised right hand and in the background are a tower and the walls of a city. Neptune and the dolphins are symbolic of seafaring, exploration, and trade among nations. The

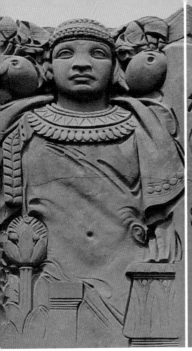
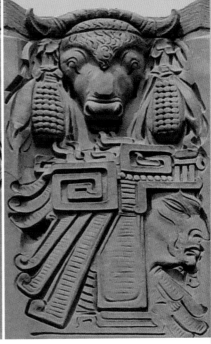

walls and tower represent the power of an established, civilized society. *Africa* is illustrated by a dignified figure in native dress with a broad pectoral of beads and a cloth draped over his shoulders. A scepter is placed on his right side, indicating high rank and authority. A geometric structure, a shaft of wheat, and large ripe fruit complete the imagery. The details establish the figure's status as a prosperous nobleman, and the symbols indicate the agricultural wealth of the continent. *The Americas* is represented by a mammoth buffalo head, flanked by fat ears of corn, representing the largesse of North America. A Mayan head and geometric designs are symbolic of Central and South America. Each carving communicates the vastness, history, and indigenous abundance found in the continents. The four scenes are related compositionally by their themes, size, and boldness of design.

131

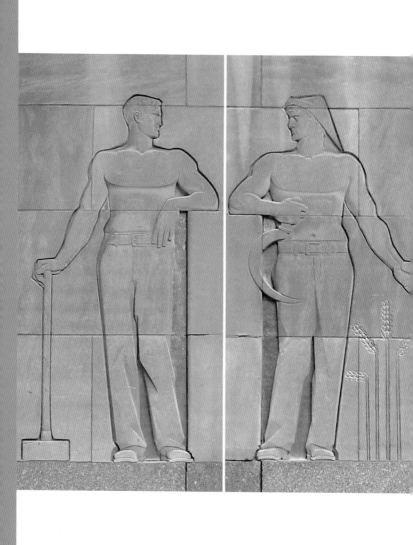

Architectural ornamentation was placed on the parts of the building most often viewed, such as the entrance, main façade, or lobby. Frequently, Art Deco ornamentation was not just decorative—it was created to make a statement about the builder, the tenant, an ideology, or even a way of life. These two heroic-sized carvings represent the commercial activities of industry and agriculture. Statements about civilization, they depict universal activities, not individuals. The carvings are placed at street level, flanking the main entrance. One figure holds a shovel, symbolizing industry. The other figure holds a scythe in one hand and, with his other hand, gestures to shafts of wheat, representing the harvest, or agriculture. This piece is a straightforward interpretation of a common Art Deco theme—workers and their work. Both figures lean on partially gilded plinths flanking the doorway. Their bodies are sculpted in fixed frontal poses with their heads turned toward the entrance, creating an aura through which all must pass. Carved into the smooth, flat stone of the building's façade and outlined with gilding, the sculptures are in low relief, level with the surface of the wall. They are strong, idealized figures, signifying the roots of prosperity in America and promoting its work ethic. The placement and unity of the workers and the entrance relate to figures occupying similar positions on church entrances, heralding the values found within the building. In this instance, they suggest an earnest attitude toward commerce. The simplicity and formality of the carvings, and their size, admirably frame the entrance.

INDUSTRY and AGRICUTURE

Carl Paul Jennewein
(1890–1978)

Installed
1937

Type
Intaglio carving

Media
Carved and gilded limestone

Measurements
Approximately 8 feet high

Location
One Rockefeller Plaza main entrance

MAN AND NATURE

Carl Milles
(1875–1955)

Installed
1937

Type
Three-part
sculptural relief
(central carving shown)

Media
Carved Michigan
pine and handcrafted
sterling silver

Location
Main lobby west wall

The sections of this three-part sculpture are quite large and carved in high relief. However, many visitors do not notice them because they are placed high up on the west lobby wall. The theme was taken from the nineteen-century German poet Johann Gottfried Seume, who wrote, "Where song is. Pause and listen; evil people have no song." On the right is the figure of a faun, a cloven-hoofed creature that is part man and part goat. Aggressively pushing branches and plants (nature) away, it symbolizes evil. On the left, a nymph contentedly rests within nature in the form of foliage. She represents virtue and the wholesomeness present in nature. The central figure found between these symbols of good and evil is mankind. He is depicted as a rider who has halted his horse and raised his head to listen to a bird's song. The small bird is perched on a branch above his head and can be difficult to detect. Periodically, the bird sings a song that was recorded from a clarino, the Mexican nightingale. It is made of sterling silver and is motorized—its wings flutter and its beak opens. The silver bird and the wood figures were created at Cranbrook, a school in Michigan where Carl Milles was director of sculpture. Milles's students participated in the creation of the sculptures. The figures were carved from huge blocks of wood formed by gluing hundreds of thick dried planks of wood together, which were then held under great pressure long enough for the adhesive to thoroughly set. The wood is stained overall reddish brown with golden highlights and darker coloration in the recesses. The silver bird and its mechanism were created in the Cranbrook jewelry studio. It is believed to be the first sculpture in America to incorporate sound and motion.

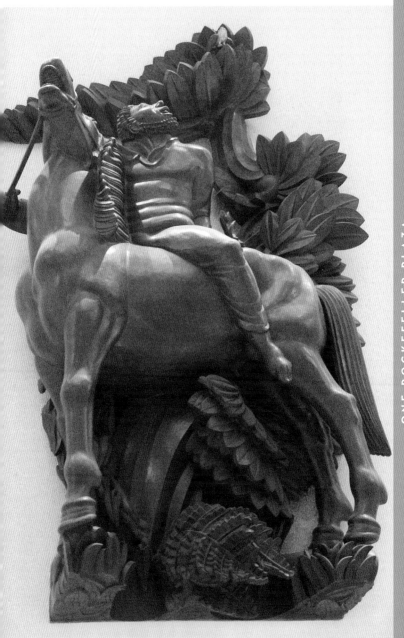

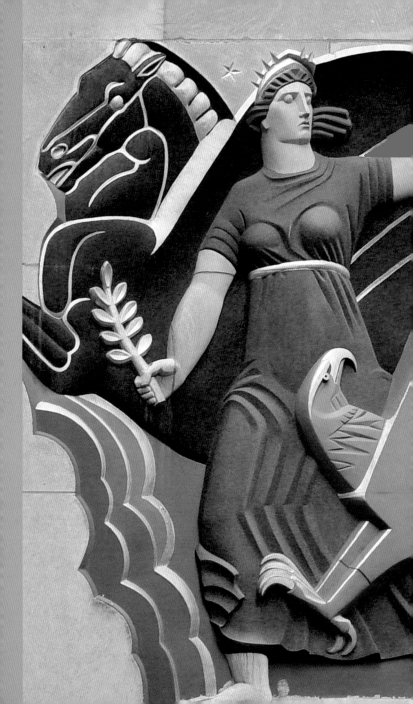

This bas-relief is an icon of the Art Deco style. It has all the primary characteristics—it is allegorical; it has bold, flat, geometric shapes, strong colors, and stylized forms; and, above all, it is decorative. The main character is Columbia, the traditional female symbol of America. A large athletic figure dressed in a simple peasant dress, she is clearly the dominant figure in the composition and is placed in its center, striding across the panel. Her face is composed and devoid of any emotion. One of her hands is raised, holding the flame of divine fire aloft. Her other hand bears an olive branch, the symbol of peace. The mythological horse Pegasus is placed behind her. He is the symbol of inspiration and depicted as a magnificent creature, his massive wings rising above Columbia's head. The fore hooves of Pegasus are lifted as if he is pawing the air or leaping. An eagle, symbolizing power, is in the foreground and appears to be descending in preparation to setting down. His wings are spread, his talons open, and his head turned upward toward the pan of divine fire. The three figures are set against a deep red background and blue stylized clouds edged in gold. Golden stars are carved into the limestone near Pegasus's hooves as if caused by the striking of his hooves upon the ground. The flat, low-relief is level with the stone façade. This work was a late addition to the building, and the stone used to carve the plaque was already set into the building and was not of sculptural quality, resulting in Lawrie having to recarve some areas after Piccirilli Brothers completed their work. This was an unusual task for Lawrie since he ordinarily left all carving to the technicians. In this piece, the coloration designed by Leon V. Solon, is as important as the carving.

PROGRESS

Lee Lawrie
(1877–1963)

Model-maker
Alex Mascetti

Carver
Piccirilli Brothers

Installed
1937

Type
Intaglio carving

Media
Carved, polychrome-painted and gilded limestone

Location
Above Forty-ninth Street entrance

THE JOY OF LIFE

Attilio Piccirilli
(1868–1945)

Installed
1937

Type
Bas-relief

Carver
Piccirilli Brothers

Media
Carved, polychrome-painted and gilded limestone

Location
Above Forty-eighth Street entrance

In this carving, Attilio Piccirilli created an unusual theme for a work of art in Rockefeller Center. John D. Rockefeller Jr., the developer of the Center, was by all accounts a reserved man who advocated temperance. In this colorful scene, however, the "joy" of life is wine. The main character is Bacchus, the Roman god of wine and revelry. Bacchus taught mankind the cultivation of the grape and then winemaking. Bacchus is depicted lolling on the ground, in the center of the scene, holding a bunch of gilded grapes overhead. He appears narcissistic, fully enjoying and endorsing a rakish life—a real rascal. Surrounding him are nude and semiclad figures transporting vessels of wine or just standing around. Aside from the equally conceited female figure with the long, flowing golden hair, the group seems a bit more circumspect. They stare down at him and appear to be patiently awaiting something or someone. The bas-relief is colorful, decorative, and lighthearted. The colors are as important as the carving—the figures are set against a brilliant blue sky strewn with a multitude of flowerlike gilded rosettes. Their bodies are painted gray like the surrounding limestone façade of the building, their togas are a pale brown, and their hair and the vessels they carry are gilded. Leon V. Solon is credited with designing the coloration. The location of the bas-relief is not ideal as it faces some rather unappealing commercial buildings that are not part of the Center. In spite of the poor location, Attilio Piccirilli created a pictorial bas-relief of great elegance that, as sheer architectural embellishment, is both unusual and delightful.

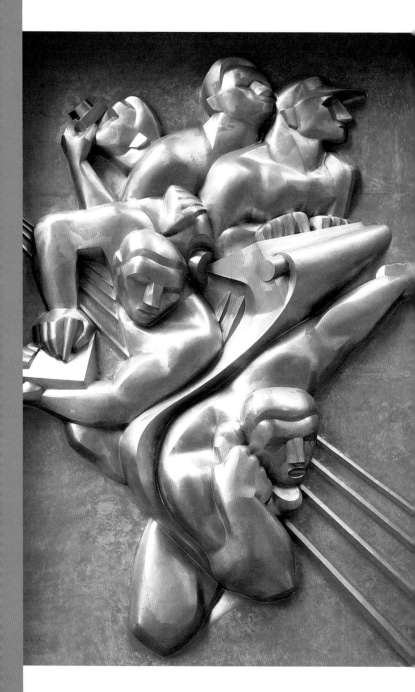

This dynamic plaque soars above the entrance to the building, symbolizing the business of the former major tenant, the Associated Press. Although Associated Press relocated in 2004, Noguchi's forceful sculpture remains the quintessential symbol of that business and is one of the major Art Deco works in the Center. It depicts five journalists focused on getting a scoop—the reporter with his pad, the newsman on the telephone, the reporter typing out his story, the photographer recording events, and the newsman hearing the news as it comes in on the wire. AP's worldwide network is symbolized by diagonal radiating lines extending across the plaque. Isamu Noguchi won this commission in a nationwide contest held by the Rockefeller Corporation in 1939. The composition is action-packed and forceful. Noguchi used intense angles and smooth planes to create a fast-paced rhythm, filling the scene with the energy of a newsroom. Dramatically foreshortened, the figures appear to spring off the wall. This work is the first heroic-sized sculpture ever cast in stainless steel and demonstrates the artist's and casters' mastery of the medium. The piece was cast in nine parts, milled and finished so precisely that the joints are not visible from the street. After it was installed, Noguchi hand-finished the work and adjusted the surface by augmenting and diffusing the reflective quality of the metal. Noguchi is best known for his abstract works. This was one his last figurative works, and the only time he employed stainless steel as an artistic medium.

NEWS

Isamu Noguchi
(1904–1988)

Installed
April 29, 1940

Type
Low-relief panel

Foundry
General Alloys,
Boston, Massachusetts

Medium
Cast stainless steel

Measurements
22 feet high, 17 feet wide

Weight
10 tons

Location
Above 50 Rockefeller
Plaza main entrance

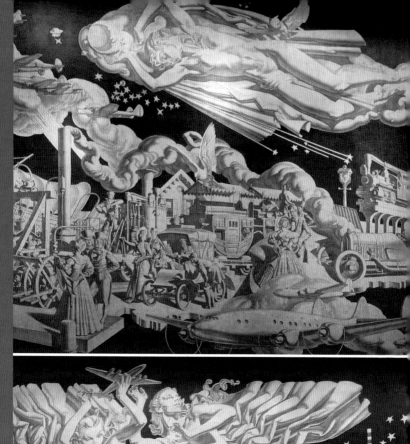

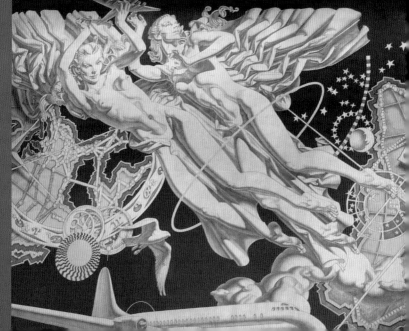

Major commercial air travel began after World War II, and Eastern Airlines was the primary tenant of this building. Dean Cornwell, a well-known illustrator, was commissioned to create a mural depicting the advances of transportation, the development of long-range transport planes, and the glory of Eastern Airlines' famed silver fleet. Cornwell's mural spans three walls of the lobby and its parts are subtitled *Night Flight, New World Unity,* and *Day Flight.* In montage fashion, the murals start with outmoded means of transportation important to the development of America: the steamboat, the prairie wagon, and the locomotive. The artist also referenced a flight of the imagination—Leonardo da Vinci's fifteenth century design for a flying machine. Whimsically, Cornwell alluded to speed by including a peregrine falcon, the fastest bird on earth. Throughout the murals, various airplanes soar through the skies under the aegis of goddesses. Cornwell limited his palette to three colors: crimson for the background, gold leaf for the continents and the seas, and silver leaf for the airplanes and the goddesses. The north panels' sleeping goddess, symbolizing *Night Flight,* floats through the heavens near stars and the moon. Planes fly around her, symbolizing the ability of commercial airlines to fly at night. The famed war hero and race-car driver, Eddie Rickenbacker, is depicted in his race car. He was president of Eastern Airlines at the time the mural was commissioned. In the central panel, *New World Unity,* pictures two goddesses surrounded by a gold ring symbolizing the unity of the continents through air travel. Below the goddesses is a huge commercial plane flying toward the viewer. The south-panel goddess represents *Day Flight* as she glides through the sky with eyes wide open, grasping the brightly burning sun in her hands. Below this goddess, outmoded means of transportation are juxtaposed with a fleet of modern, gleaming airplanes. Wilmuth Stevens, the assistant muralist, modeled for all the goddesses.

THE HISTORY OF TRANSPORTATION

Dean Cornwell
(1892–1960)

Installed
May 1946

Type
Tripartite mural (north and west panels shown)

Media
Oil paint, gold and silver leaf on canvas

Measurements
Center panel
54 feet wide, 20 feet high

Location
10 Rockefeller Plaza
main lobby

OSCAR BRUNO BACH

Born December 13, 1884
Breslau, Germany

Died May 4, 1957
New York City, New York

Sculptor, designer, and metallurgist. Bach studied at the Berlin Royal Art Academy. He immigrated from Germany to England, then to the United States in 1913. He was well known for developing a corrosion-resistant process for ferrous metals, enamelwork and metal repoussé applications, and fabrications of large exterior plaques. His works can be found at the Empire State Building and Riverside Church in New York City and Yale University in New Haven, Connecticut.

Radio City Music Hall. Title: *Dance, Drama,* and *Song* (plaques); Fabricated the designs of Hildreth Meiere; Location: Fiftieth Street façade about 70 feet above street level.

HENRY BILLINGS

Born July 13, 1901
New York City, New York

Died 1985
New York City, New York

Easel painter, illustrator, and muralist. Billings's work can be found in the Whitney Museum of American Art, New York City, and the W. A. White Library, Kansas State Teachers College. He taught at Bard College from 1935 to 1953 and at the Art Students League summer school from 1960 to 1961.

Radio City Music Hall. Title: *Panther* (mural); Location: wall of third-mezzanine ladies' lounge.

LOUIS BOUCHE

Born 1896
New York City, New York

Died 1969
Old Chatham, New York

Easel painter and muralist. Bouche studied at the École de la Grande Chaumière and the École des Beaux-Arts in Paris. He taught at the Art Students League, New York City, from 1934 to 1969. He received a Guggenheim Fellowship in 1933. His work can be found in the collections of the Metropolitan Museum of Art and the Whitney Museum of American Art, New York City; the Eisenhower Foundation Museum, Abilene, Kansas; and the Department of the Interior, Washington, D.C. His work was also exhibited at the American Academy of Arts and Letters, New York City, in 1970.

Radio City Music Hall. Title: *The Phantasmagoria of the Theater* (murals/five vignettes); Location: walls of Main Lounge.

Easel painter, muralist, printmaker, designer, and illustrator. Frank Brangwyn was born in Belgium of Welsh and English parents. His first work was exhibited by the British Royal Academy when he was eighteen. He designed furniture, ceramics, fabrics, prints, and posters. In 1952 he became the first living artist to have a one-man show at the Royal Academy. He decorated the Missouri State Capitol and the Royal Exchange in London.

30 Rockefeller Plaza. Collectively titled: *Man in Search for Eternal Truth;* Individually titled: *Man the Creator; Man Labouring; Man the Master,* and *Man's Ultimate Destiny* (four murals); Location: south corridor walls off main lobby.

La Maison Francaise, 610 Fifth Avenue. Title: *The Question Mark (Le Point d'Interrogation)* (model airplane); Location: display case in center of lobby off Channel Gardens entrance.

Sculptor and model maker. Rene Chambellan attended New York University from 1912 to 1914 and the Beaux-Arts Institute of Design from 1914 to 1917. He went to Paris in 1918 to study for a year at the École Julien. Chambellan was an architectural modeler and sculptor. His work in New York City includes ornamentation for the Criminal Courts Building, architectural decoration for King's County Hospital, the North Corona Gate at the 1939 Worlds Fair, and foyer panels in the Chanin Building.

Channel Gardens. Titles: *Leadership, Will, Thought, Imagination, Energy,* and *Alertness* (six fountainhead sculptures); Location: east ends of the six pools. Title: *Sea Creatures* in the form of turtles, crabs, and starfish (decorative drain covers); Location: west ends of the six pools.

British Empire Building, 620 Fifth Avenue. Title: *British Coat of Arms* (cartouche); Location: over main entrance. Title: *Motifs from the Coats of Arms of The British Isles* (four panels); Location: spandrels on Fifth Avenue facade.

La Maison Francaise, 610 Fifth Avenue. Title: *Pageant of French History* (four panels); Location: spandrels on Fifth Avenue façade.

SIR FRANK BRANGWYN

Born 1867
Bruges, Belgium

Died June 11, 1956
Ditchling, England

CARTIER SILVERSMITHS

RENÉ PAUL CHAMBELLAN

Born 1893
West Hoboken,
New Jersey

Died November 11, 1955
Grantwood, New Jersey

Radio City Music Hall. *Acts from Vaudeville* (six plaques); Location: under marquee and above main entrance. Title: *Scenes from Theater* (sixty-six plaques); Location: auditorium doors. Title: *Musicians* (eight panels); Location: exterior of elevator doors.

VALERIE CLAREBOUT

Dates unknown

Born in Farncombe, Surrey, England

Painter and sculptor. Clarebout studied at the Royal Academy in London and in 1934 at the Académie Julien in Paris. In 1937 Clarebout moved to Buenos Aires. She returned to England in 1942 and served as a volunteer in the Air Defense before going back to Buenos Aires to study painting. In 1949 she moved to France and then in the early 1950s to America, where she continued her work as a sculptor.

Channel Gardens. Title: *Christmas Angels* (decorative figures); Location: Installed in the gardens surrounding the pools (displayed during Christmas holidays).

DEAN CORNWELL

Born 1892
Louisville, Kentucky

Died 1960

Painter, muralist, and illustrator. Cornwell studied at the Art Institute of Chicago and exhibited at the National Academy of Design in New York. He had illustrations in leading magazines and was awarded a gold medal by the Architectural League of New York. He executed two murals in gold and silver leaf for the General Motors Building in New York City and the 1939 World's Fair. He illustrated the books *The Robe* and *The Big Fisherman* by Lloyd Douglas.

10 Rockefeller Plaza. Title: *The History of Transportation* (mural); Location: three walls of main lobby.

STUART DAVIS

Born 1894
Philadelphia,
Pennsylvania

Died 1964
Connecticut

Painter. Davis studied at the Henri School of Art in New York City. His painting was featured in the New York World's Fair Communications Building and representative works are included in the collections of Indiana University, the University of Georgia, the Museum of Modern Art, and the Whitney Museum of American Art in New York City. In the 1930s he was a member of the Easel Painters Project of the Works Progress Administration (WPA).

Radio City Music Hall. Title: *Untitled Mural,* also known as *Men Without Women*; Location: wall of men's lounge off main lounge.

Designer and printmaker. Deskey studied at the University of California, the Chicago Art Institute, and the École de la Grande Chaumière in Paris. He was a major contributor to the 1939 World's Fair and designed furniture in chrome, aluminum, and Bakelite for corporations throughout America including E. R. Squibb and Sons and the Music Corporation of America. Deskey also designed packaging for Proctor & Gamble and Johnson & Johnson. His highly recognizable designs for Tide detergent, Prell shampoo, and Crest toothpaste are firmly rooted in consumer culture.

Radio City Music Hall. Furnishings and coordination of the decoration including: Title: *Nicotine* (wall covering); Location: walls of second-mezzanine men's lounge. Title: *The Mirror Room* (interior design); Location: first-mezzanine ladies lounge. Title: *Light fixtures* (interior design element); Location: entrance lobby. Title: *Wall Covering*; Location: third-floor ladies' lounge.

Painter, muralist, and mosaicist. Faulkner studied at the American Academy in Rome. His work is found at the National Archives, Washington, D.C.; the State Capitol in Salem, Oregon; and the State House in Concord, New Hampshire.

1250 Avenue of the Americas. Title: *Intelligence Awakening Mankind* (mosaic); Location: 1250 Avenue of the Americas loggia above the entrances.

Sculptor. Friedlander studied at the École des Beaux-Arts in Brussels and Paris. He was awarded the Prix de Rome in 1913. His works include the Washington Memorial Arch, Valley Forge, Pennsylvania; and portraits of Beethoven and Bach at the Eastman School of Music, Rochester, New York.

30 Rockefeller Plaza. Title: *Radio* (sculpture); Location: pylons flanking Fiftieth Street entrance. Title: *Television* (sculpture); Location: pylons flanking Forty-ninth Street entrance.

DONALD DESKEY

Born 1894
Blue Earth, Minnesota

Died 1989

BARRY FAULKNER

Born 1881
Keene, New Hampshire

Died 1966

LEO FRIEDLANDER

Born 1890
New York City, New York

Died 1969

ROBERT GARRISON

Born 1895
Fort Dodge, Iowa

Died 1946

Sculptor. Garrison studied with Gutzon Borglum. His works include a frieze for the Midland Savings and Trust Co., Denver, and a fountain for Kings County Hospital, Brooklyn, New York. He was a consulting sculptor for Riverside Church in New York City, and was awarded a gold medal at the Oklahoma State Fair in 1913.

1270 Avenue of the Americas. Title: *Morning, Present,* and *Evening* (three stone panels); Location: above main entrance.

WITOLD GORDON

Born 1898

Died 1947

Painter, muralist, illustrator, and costume designer. Gordon studied in Paris. He designed costumes for the Metropolitan Opera, New York.

Radio City Music Hall. Title: *Continents* (mural); Location: walls of first-mezzanine men's lounge. Title: *History of Cosmetics* (murals); Location: walls of ladies' lounge off Grand Lounge.

MICHIO IHARA

Born November 17, 1928
Paris, France

Sculptor. A Japanese citizen, Ihara studied at the Tokyo University of Fine Arts and the Massachusetts Institute of Technology under a Fulbright grant. He had his first one-man show at the Staempfli Gallery in New York City and has won architectural commissions in Japan, New Zealand, and the United States. A self-described architectural sculptor, he currently lives and works in Massachusetts.

International Building, 630 Fifth Avenue. Title: *Untitled,* also known as *Light and Movement* (ten-part multimedia sculpture); Location: north and south walls of main lobby.

ALFRED JANNIOT

Born 1889
France

Died 1969
France

Sculptor and painter. Janniot was a member of the French Academy in Rome and awarded the Legion of Honor following the Exposition des Arts Decoratifs in 1926 for the importance of his work to French prestige and economy. His most famous sculptural works in France are *Tapestry in Stone* at the Oceanographic Museum in Paris and a memorial to the war dead in Nice.

La Maison Francaise, 610 Fifth Avenue. Title: *Friendship Between America and France*: (bas-relief); Location: above main entrance. Title: *Torch of Freedom* (cartouche); Location: Fifth Avenue façade.

Sculptor. Jennewein immigrated to the United States in 1907 and became a citizen in 1915. He studied at the Art Students League and was a Prix de Rome scholar. His works can be found at the Brooklyn Central Library; the Arlington Memorial Bridge, Washington, D.C.; the Metropolitan Museum of Art; Brookgreen Gardens, the South Carolina Museum of Fine Arts; and the Tampa Museum of Fine Arts, Florida.

British Empire Building, 620 Fifth Avenue. Title: *Industries of the British Empire* (bas-relief); Location: above 620 Fifth Avenue (main) entrance.

One Rockefeller Plaza. Title: *Industry and Agriculture* (two bas-reliefs); Location: flanking main entrance at street level.

Painter, printmaker, and muralist. Kuniyoshi studied at the Los Angeles School of Art, as well as the National Academy of Design and the Art Students League in New York City. He was a member of the Woodstock Artists Association (WAA) and president of the Artists Equity Association in the 1940s. His works can be found at the Library of Congress, the Chicago Institute of Art, the Metropolitan Museum of Art, and the Whitney Museum of American Art in New York City.

Radio City Music Hall. Title: *Untitled*, also known as *Exotic Flowers* (mural); Location: walls and ceiling of second-mezzanine ladies' lounge.

Painter, printmaker, and sculptor. Kushner received his B.A. from the University of California. His works can be found in the collections of the Metropolitan Museum of Art, the Brooklyn Museum, the Museum of Modern Art, and the Whitney Museum of American Art in New York City; the Los Angeles County Museum; and the Tate Museum, London, England.

1270 Avenue of the Americas. Title: *Sentinels* (sculpture); Location: lobby.

CARL PAUL JENNEWEIN

Born 1890
Stuttgart, Germany

Died 1978
New York

YASUO KUNIYOSHI

Born 1893
Okayama, Japan

Died 1953
Woodstock, New York

ROBERT KUSHNER

Born 1949
California

GASTON LACHAISE

Born March 19, 1882
Paris, France

Died October 18, 1935
New York

Sculptor. Lachaise's father was a prominent cabinet-maker who designed the Eiffel apartment in the renowned tower in Paris. At thirteen, Gaston was enrolled in the École Bernard Palissy, an elite school for artist-craftsmen in Europe. Three years later he was granted early admission to Académie Nationale des Beaux-Arts. His looming conscription into the French army inspired him to move to Boston where he became an assistant to the academic sculptor Henry Hudson Kitson. He met Gutzon Borglum and Paul Manship in New York, and soon became Manship's studio assistant. By 1927 he had his first one-man show; commissions followed and 1930 saw his figure titled *Man* exhibited at the newly opened Museum of Modern Art. In 1935 the Museum of Modern Art gave him a one-man show, just eight months before his premature death at fifty-three from leukemia.

1250 Avenue of the Americas. Title: *Aspects of Mankind* (four stone carvings); Location: façade near seventh floor.

International Building, 630 Fifth Avenue. Titles: *To Commemorate the Workmen of the Center*, also known as *Demolition* and *Construction* (two bas-reliefs); Location: above 45 Rockefeller Plaza entrances.

ROBERT LAURENT

Born June 29, 1890
Concarneau, France

Died April 20, 1970
Cape Neddick, Maine

Sculptor. Hamilton Easter Field, an American painter, editor and teacher, was a surrogate father and mentor to Robert Laurent. Laurent's first exhibit was a two-man show he shared with Field at the Daniel Gallery in 1915 and his first one-man show was at the Bourgeois Gallery in New York City in 1922. Laurent taught at the Art Students League, Vassar and Goucher colleges, and both the Corcoran Gallery and the Brooklyn Museum art schools before settling into a permanent position in 1942 as resident sculptor at Indiana University.

Radio City Music Hall. Title: *Girl and Goose* (sculpture); Location: first mezzanine.

Sculptor. Lawrie earned his B.F.A. at Yale University and received an honorary master's degree there in 1932. He studied with Augustus Saint-Gaudens. Well-known as an architectural sculptor, his works can be found at the U.S. Military Academy, West Point; St. Thomas Church and Church of St. Vincent Ferrer, New York City; Boys Town, Nebraska; and the Soldiers and Sailors Memorial Bridge, Harrisburg, Pennsylvania.

30 Rockefeller Plaza. Titles: *Wisdom* with *Sound* and *Light* (sculpture group); Location: above main entrances.

International Building, 630 Fifth Avenue. Title: *Atlas* (sculpture); Location: forecourt main entrance. Title: *Saint Francis of Assisi* (bas-relief); Location: above 9 West Fiftieth Street entrance. Title: *Swords into Plowshares, Columbia Greeting a Woman,* and *Boatman* (three-part bas-relief); Location: above 19 West Fiftieth Street entrance. Title: *The Meaning of the International Building* (sculptural grille); Location: above 29 West Fiftieth Street entrance. Title: *Cornucopia of Plenty* (bas-relief); Location: above 10 West Fifty-first Street entrance. Title: *Fourteen Coats of Arms* (bas-relief); Location: above 20 West Fifty-first Street entrance.

La Maison Francaise. Title: *Fleur-de-lis* (bas-relief); Location: above 9 West Forty-ninth Street entrance; *The Sower* (bas-relief); Location: above Channel Gardens entrance.

British Empire Building. Title: *Heraldic Lions* (bas-relief); Location: above 10 West 50th Street entrance. Title: *Winged Mercury* (bas-relief); Location: above Channel Gardens entrance.

One Rockefeller Plaza. Title: *Progress* (bas-relief). Location: above Forty-ninth Street entrance.

Sculptor. Lentelli came to the United States at age twenty-four and was naturalized nine years later. His work can be found in Brookgreen Gardens, South Carolina; the Department of the Interior in Washington, D.C.; and in the Oakland Museum in California, Pittsburg, Pennsylvania, and Denver, Colorado.

LEE LAWRIE

Born 1877
Rixdorf, Germany

Died 1963

LEO LENTELLI

Born 1879, Bologna, Italy

Died 1961

Palazzo d'Italia, 626 Fifth Avenue. Title: *Four Periods in Italian History* (carvings); Location: spandrels on Fifth Avenue façade.

International Building North, 636 Fifth Avenue. Title: *Four Continents* (carvings); Location: spandrels on Fifth Avenue façade.

GWEN CREIGHTON LUX

Born 1908
Chicago, Illinois

Died 2001
Honolulu, Hawaii

Sculptor, industrial designer, mosaicist, and potter. Lux was a member of Associated American Artists. She designed pottery at Stonelain Pottery. Collections and installations include the McGraw-Hill Building, Chicago; *Four Freedoms,* a fiberglass sculpture for the first class dining room, SS *United States;* and *Education,* a bronze sculpture for the New York Department of Education.

Radio City Music Hall. Title: *Eve* (sculpture); Location: first mezzanine at top of Fiftieth Street staircase.

PAUL MANSHIP

Born December 24, 1885
St. Paul, Minnesota

Died January 31, 1966
New York City, New York

Sculptor. Manship's first training was at the St. Paul Institute of Art but he left school by the time he was eighteen to work for an engraving company and independently as a designer and illustrator. In 1905 he moved to New York City where he became assistant to Solon H. Borglum and two years later to Isidore Konti. Manship won the Prix de Rome in 1909 and spent the next several years in Rome studying at the American Academy. He returned to New York in 1912 and soon established himself—his many commissions included some from Mrs. Rockefeller. Manship maintained a studio in Paris from 1922 to 1927, during which time he spent a year teaching sculpture at the American Academy in Rome. Following his stay in Europe, Manship returned once again to New York to complete some of his most famous commissions, including those of the statue of *Prometheus* at Rockefeller Center and the *Celestial Sphere* in Geneva, Switzerland.

Lower Plaza. Title: *Prometheus* (sculpture); Location: fountain on west side of skating rink.

Channel Gardens and Promenade. Title: *Mankind Figures* also known as *Youth and Maiden* (two sculptures); Location: flanking staircase from Promenade to Lower Plaza.

Sculptor and painter. Manzu studied at the Accademia Cicognini, Verona. His major installations are *The Door of Death* of the Basilica di San Pietro in the Vatican; *The Door of Love*, Salzburg, Austria; and *The Door of War and Peace*, Rotterdam, the Netherlands. The esquisse of *The Door of Death* is located at the Hakone Open Air Museum, Japan. Smaller works include *Cardinale Sedute* (bronze), *Cardinale Sedute* (marble), and *Testa di Penerope* (bronze). Other work can be found in the National Museum of Manzu, founded in 1969 and located near Rome, Italy; and the Tokyo National Museum of Modern Art, Japan.

Palazzo d'Italia, 626 Fifth Avenue. Title: *Italia* (bas-relief); Location: above 626 Fifth Avenue (main) entrance.

International Building 636 Fifth Avenue. Title: *The Immigrant* (bas-relief); Location: ground level near Fiftieth Street entrance.

GIACOMO MANZU

Born 1908
Bergamo, Italy

Died 1994
Ardea, Rome, Italy

Sculptor and muralist. Meiere studied in Florence, Italy, and at the Art Students League in New York City. Her work is found in St. Patrick's Cathedral and St. Bartholomew's Church, New York City; the National Academy of Sciences in Washington, D.C.; and the Nebraska State Capitol Building; as well as ornamentation in both the House and the Senate wings of the U.S. Capitol in Washington, D.C. Meiere was awarded the Architectural League gold medal for mural decoration.

Radio City Music Hall. Title: *Dance, Drama,* and *Song* (three rondels); Location: Fiftieth Street façade about seventy feet above ground level.

HILDRETH M. MEIERE

Born 1893
New York City, New York

Died 1961

Designer of woven and printed textiles and fabrics. Mergentime was a pupil of Ilonka Karasz and exhibited at the Brooklyn Museum and AUDAC Shows. She designed extensively for the fabric manufacturers Kohn-Hall-Marx Co. and Schwartzenbach-Huber.

Radio City Music Hall. Title: *Design for Carpet*; Location: Grand Lounge near elevators. Title: *Design for wall covering*; Location: third-mezzanine ladies' lounge.

MARGUERITA MERGENTIME

Birth date unknown
New York

Died 1941, New York

CARL MILLES

Born 1875
Uppsala, Sweden

Died 1955
Stockholm, Sweden

Sculptor. Milles was a professor of art at the Royal Academy of Stockholm and recognized in Sweden as its leading sculptor. In 1929 he immigrated to the United States, becoming a citizen in 1945. He taught at the Cranbrook School in Michigan until the early 1950s, when he returned to Sweden and established the Milles Garden, a museum for his own works and collection.

One Rockefeller Plaza. Title: *Man and Nature* (three-part sculpture); Location: main lobby west wall.

ISAMU NOGUCHI

Born November 17, 1904
Los Angeles, California

Died 1988
New York City, New York

Sculptor, theatrical, and industrial designer. From the age of two, Noguchi spent his childhood in Japan. His father was a Japanese poet and his mother an American writer and teacher. Noguchi was sent back to the United States as a teenager to attend high school. By the time he was eighteen, he apprenticed briefly to Gutzon Borglum who told him he would never become a sculptor—motivating him to move to New York City and enroll in medical school at Columbia University. Fortunately, he continued to sculpt part-time and in 1924 had his first one-man show at the Eugene Schoen Gallery. Noguchi received a Guggenheim Fellowship in 1927 and went to study in Paris where he became a studio assistant to Constantin Brancusi and met Alexander Calder. The following years brought travel and studies in places like China and Japan before he settled down again in New York. Noguchi's artistic interests ranged from ballet sets for Martha Graham to designing playgrounds and furniture, not to mention sculpture. In 1956 he designed the gardens at UNESCO in Paris and in 1951 the Hiroshima Peace Park. The work of Noguchi is to be found in every major museum in the world. His 1932 sculptural entry *News* won the invitational contest for placement at the Associated Press Building in Rockefeller Center.

The Associated Press Building, 50 Rockefeller Plaza. Title: *News* (bas-relief); Location: above 50 Rockefeller Plaza (main) entrance.

Sculptor, model maker, and stone carver. Piccirilli studied at the Academia San Luca, Rome. He immigrated to the United States in 1887 with his parents and six brothers. In 1893 he and his brothers opened an atelier and workshop on 142nd Street in the Mott Haven section of the Bronx. Their studio specialized in stone—molding, modeling, and carving for the leading sculptors of their day. Major works in New York City include the *Maine Monument*, Columbus Circle; the *Soldiers Monument* in the Bronx; the pediment of the New York Stock Exchange; the *Lions* at the Main Branch of the New York Public Library; and the *Fireman's Memorial* on Riverside Drive.

International Building North, 636 Fifth Avenue. Title: *Youth Leading Industry* (glass panel); Location: above 636 Fifth Avenue entrance. Title: *Commerce and Industry with a Caduceus* (cartouche); Location: above Fifth Avenue entrance on façade.

One Rockefeller Plaza. Title: *The Joy of Life* (bas-relief); Location: above 15 West Forty-eighth Street entrance.

Fabric designer and author. Reeves studied at Pratt Institute, the San Francisco School of Design, and the Académie Moderne in Paris, where she studied painting with Fernand Leger. Her flat geometric style was ideally suited to fabrics and textiles. By 1920 she had earned a reputation for hand-printed textiles and was recognized as a leader in the American modern design movement. Her work can be found in the Metropolitan Museum; Cooper-Hewitt National Design Museum, Smithsonian Institution; Brooklyn Museum; Cleveland Museum; Chicago Art Institute; and the Victoria and Albert Museum in London. She is the author of the book *Cire Perdue Casting in India* (1962).

Radio City Music Hall. Title: *Musical Instruments* (carpet design); Location: Grand Foyer and mezzanines. Title: *Scenes from Theater* (wall covering); Location: rear and side walls of Auditorium.

ATTILIO PICCIRILLI

Born 1868
Massa, Italy

Died October 8, 1945
New York City, New York

RUTH REEVES

Born 1892
California

Died 1960
New Delhi, India

ARTISTS' BIOGRAPHIES AND LOCATION OF ART

JOSÉ MARÍA SERT

Born 1876
Barcelona, Spain

Died 1945
Paris, France

Painter and muralist. Sert spent his adult life living in Paris and was internationally famous as a mural painter. His works can be found in private homes in Argentina, Spain, and Florida. In public buildings, his work can be found in the Hôtel de Ville, Paris, France; the League of Nations, Geneva, Switzerland; and the Waldorf-Astoria Hotel, New York. His masterwork is the Cathedral of Vich in Catalonia, Spain.

30 Rockefeller Plaza. Title: *American Progress* (mural); Location: west wall over information desk in main lobby. Title: *Time* (mural); Location: ceiling main lobby; Title: *Man's Mastery of the Material World* (the four murals are subtitled and installed in the following sequence from east to west: *Evolution of Machinery, Eradication of Disease, Abolition of Slavery,* and *Suppression of War*); Location: north corridor walls off main lobby. Title: *Contest-1940* (mural); Location: north staircase to mezzanine. Title: *Fraternity of Men* (mural); Location: north staircase to mezzanine. Title: *Spirit of Dance* (mural); Location: north wall of first elevator bank. Title: *Man's Triumph in Communication* (mural); Location: south wall of first elevator bank. Title: *Light* (mural); Location: south corridor balustrade wall; Title: *Fire* (mural); Location: north corridor balustrade wall.

EDWARD TRUMBULL

Born 1884
Michigan

Died May 1968
Pennsylvania

Muralist, painter, and colorist. Trumbull studied at the Art Students League, New York, and in London with the muralist Sir Frank Brangwyn, Great Britain. Major murals include the ceiling of the lobby in the Chrysler Building, New York; Renaissance Center, Erie, New York; the Bancroft Library, University of California at Berkeley, California; and the Heinz Administration Building, Pittsburgh, Pennsylvania. Stylistically, he was a traditionalist and was known for his bright colors and varied palette. He was affiliated with Carnegie Institute in Pittsburgh, Pennsylvania.

Radio City Music Hall (*Attributed to Edward Trumbull*). Title: *Untitled* (inlays/rondels); Location: elevator cab walls.

Muralist and mosaics. Ulreich attended Kansas City Art School and Pennsylvania Academy of the Fine Arts. An artist for the Works Progress Administration (WPA), he designed murals for the Temple Building, Chicago, and marble mosaics for the Century of Progress Exhibition, Chicago. He exhibited at the Art Director's Club, Anderson Galleries, and Dudensing Gallery.

Radio City Music Hall. Title: *Wild West* (mural); Location: third-mezzanine men's lounge.

EDWARD BUK ULREICH

Born 1889
Hungary

Died 1962
San Francisco, California

Easel painter and muralist. Winter studied at the Chicago Academy of Fine Arts. He was a winner of American Academy in Rome Scholarship. Representative works can be found at the New York Cotton Exchange Building and the Library of Congress, Washington D.C.

Radio City Music Hall. Title: *The Fountain of Youth* (mural); Location: curving wall over staircase from Grand Lobby to first mezzanine.

EZRA A. WINTER

Born 1886
Manistee, Michigan

Died 1966

Sculptor. When Zorach was four years old, his family immigrated to the United States and settled in Cleveland, Ohio. By the time he was thirteen years old, he was an apprentice to a lithographer and attended night school at the Cleveland School of Art. At nineteen he moved to New York City and enrolled at the National Academy of Design, studying with A. M. Ward and George Maynard. The following year he studied in Paris and exhibited paintings in the Salon d'Automne. Zorach later returned to New York, married, and enjoyed success with his widely exhibited paintings. In 1922 he decided to stop painting and began carving directly in stone and wood—an American revival approach to sculpture in which the material is the primary factor in the artistic statement. Krushaar Galleries gave him a one-man show in 1924. Zorach began a long career of teaching in 1929 at the Art Students League in New York. A retrospective showing of his work was held at the Whitney Museum in 1959.

Radio City Music Hall. Title: *Dancing Figure* (sculpture); Location: Grand Lounge**.**

WILLIAM ZORACH

Born 1889
Eurburg, Lithuania

Died November 15, 1966
Bath, Maine

INDEX OF ART AND ARTISTS

The Guide to the Art of Rockefeller Center
Christine Roussel

Copyright 2006 by Christine Roussel

Preface copyright 2006 by Thomas Hoving

Manufacturing by Mondadori Printing, Verona

Book design and composition by Robert L. Wiser, Silver Spring, Maryland

Library of Congress Cataloging-in-Publication Data

Roussel, Christine.
 The guide to the art of Rockefeller Center / by Christine Roussel ; photographs by Dianne Roussel and Christine Roussel ; preface by Thomas Hoving.—1st ed.
 p. cm.
 Includes bibliographical references and index.
 ISBN-13 : 978-0-393-32865-3 (pbk.)
 ISBN-10 : 0-393-32865-1 (pbk.)
 1. Art, American—New York (State)—New York—20th century. 2. Art deco—New York (State)—New York. 3. Art—Private collections—New York (State)—New York. 4. Rockefeller, John D. (John Davison), 1874–1960—Art patronage. 5. Rockefeller Center—Art collections—Guidebooks. 6. New York (N.Y.)—Guidebooks. I. Rockefeller Center. II. Title.
 N6535.N5R675 2006
 709′.040120747471—dc22

 2006002029

W. W. Norton & Company
500 Fifth Avenue, New York, NY 10110
www.wwnorton.com

W. W. Norton & Company Ltd.
Castle House, 75/76 Wells Street London, WIT 3QT

1 2 3 4 5 6 7 8 9 0

All photographs by Dianne Roussel and Christine Roussel except for Steve Micros, *Le point d'Interrogation* (page 92); and Roger Leo, *Christmas Angel* (page 102) and Lower Plaza (page 105).